DIEGO RIVERA

DIEGO RIVERA

THE SHAPING OF AN ARTIST
1889-1921

BY
FLORENCE ARQUIN

University of Oklahoma Press
Norman

International Standard Book Number: 0–8061–0903–3

Library of Congress Catalog Card Number: 71–108795

Copyright 1971 by the University of Oklahoma Press, Publishing Division of the University. Composed and printed at Norman, Oklahoma, U.S.A., by the University of Oklahoma Press. First edition.

To the memory of Diego Rivera and his artist wife, the incomparable Frida Kahlo Rivera

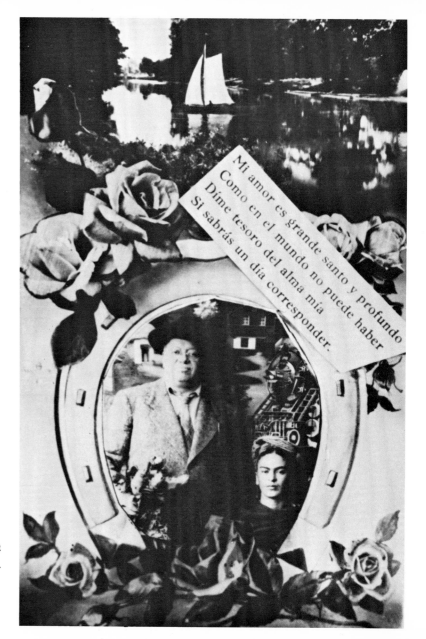

Plate 1. Diego and Frida. *From a photograph made at a fiesta, ca. 1943.* Arquin Collection.

PREFACE

The setting was Coyoacán, at the outskirts of Mexico City, and in Frida Kahlo Rivera's beautiful old colonial home—the home in which she was born, lived, and painted, and in which she died in 1954 (now the Frida Kahlo Memorial Museum). It was there, too, that she and Diego Rivera shared a full and rich twenty-five years of life together (Plates 1, 2, and 5).

I arrived early in the afternoon of May 19, 1949, with the preliminary draft of a manuscript on Diego's painting, which I had promised to read to them. It was an article about the contemporary exhibition of works by Diego that took place in August, 1949, at the National Palace of Fine Arts in Mexico City. On the day of my visit both Diego and Frida were ill. Frida sat propped against pillows on her canopied bed—the setting for the self-portrait for which she had achieved fame (Plate 3). She was vivid and picturesque as ever in an embroidered Tehuantepec huipil (Plate 4) and with scarlet ribbons plaited in her shining black hair. Facing her as he reclined in his huge old upholstered chair was Diego, engulfed in a heavy robe. He was recovering from pneumonia. Although he was temperamentally gay and possessed of a throbbing vitality and zest for life commensurate with his passion for painting and his intense need for independent creative expression, enforced inactivity left him listless and depressed. Any interruption of his work—even that resulting from illness—became "interference." It was construed as an insufferable indignity to which he could never reconcile himself without resentment and frustration—if not abject dejection—for to Diego Rivera, living and painting were indivisible. Only when at work, and once again in his own element, would he become truly alive and content.

At Frida's insistence I perched at the foot of her bed, opposite both of them, and began to read. There were no comments, no interruptions. From time to time tears rolled down Frida's cheeks, while Diego, like a great Buddha, would slowly nod his head and

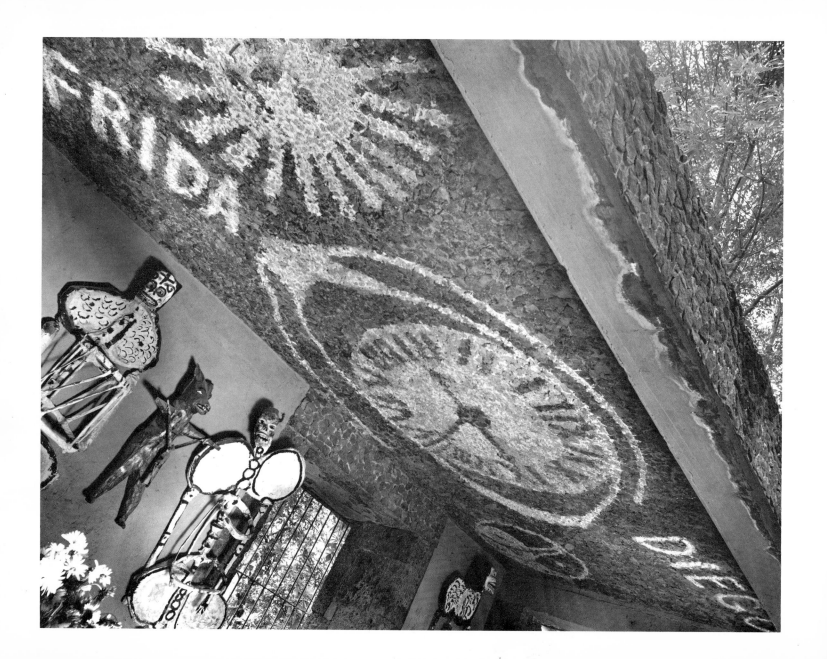

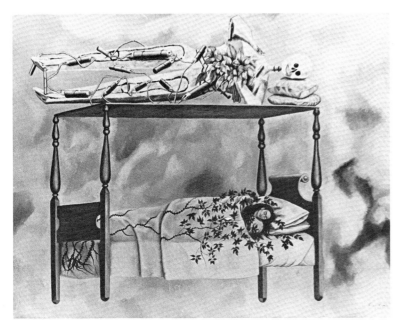

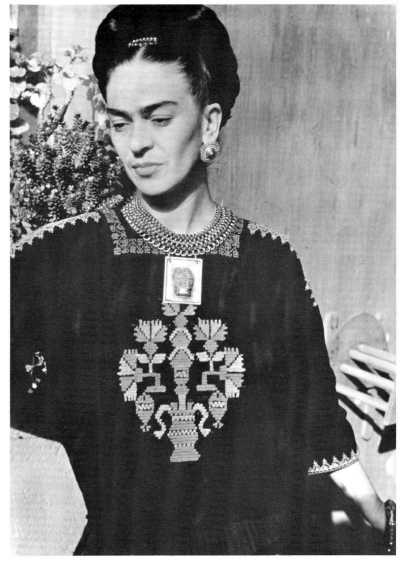

Plate 2. (left) Diego and Frida, *by Diego Rivera. Ceiling in home at Coyoacán, Mexico. Mosaic. Photograph by G. Zamora.*

Plate 3. (above) Self-Portrait in Canopied Bed, *by Frida Kahlo Rivera. Oil on tin (?), 1947. Collection of Frida Kahlo Memorial Museum, Coyoacán.*

Plate 4. (right) Frida Kahlo Rivera, *1941. Photograph by Florence Arquin.*

occasionally utter a deep sigh. The intensity of emotion engendered in that small room was such that I too could scarcely read for the constriction in my throat as I responded to the reactions of these two people who were so dear to me.

When I had finished, both Frida and Diego rose and embraced me. The next morning I received from Diego the letter which follows.

Today both Diego Rivera and Frida Kahlo are gone, but their story, on canvases and on Mexico's frescoed walls, remains for all who would see and understand.

FLORENCE ARQUIN

Chicago, Illinois
January 15, 1970

Plate 5. Diego and Frida Kahlo Rivera in patio of home at Coyoacán, Mexico, ca. 1947. Photograph by G. Zamora.

LETTER FROM DIEGO RIVERA

Mexico Mayo 20 1949

Sra. Da Florencia Arquin.
Pte

Mi muy querida y gentil amiga:

Quiero darte las gracias por el admirable articulo que has escrito sobre mi trabajo, me parece lo mejor que se ha dicho sobre él, como una lista de la evolución de mi pintura y como valorización plástica, y social.

Quiero decirte que por primera vez alguien se ha ocupado de mi pintura, en sus diferentes facetas, enfocándola por encima de todo como fale y sin enredarse en la ramazón de los márgenes del rio al seguir su corriente. Claro que pudiste hacer esto por que eres una pintora de

valor, y tu propio valer te dá la posibilidad de admitir libremente lo que puedas encontrar en los demás. Tu articulo es exelente, tanto mas exelente cuanto es enteramente objetivo y solo en el impulso sostenido y apasionado en el análisis, puede adivinarse tu afecto y camaradería maravillosa hacia mi, sin que tu sentimiento influya ni un momento sobre tu juicio, técnico claro y seguro.

Muchas gracias amiga mia

Diego Rivera

TO FLORENCE ARQUIN

<div align="center">Mexico City May 20, 1949</div>

To Florence Arquin

My very dear and thoughtful friend:

I want to thank you for the admirable article which you have written about my work. It seems to me that it is the best that has ever been said about it as an analysis of the evolution of my painting and as an evaluation of its plastic and social aspects.

I want to tell you that for the first time someone has concerned himself with my painting in its different facets, emphasizing it as such above all else and without becoming enmeshed in the lush growth of the banks of the river as you follow the current. You were able to do this because you yourself are a painter of stature and your own worth gives you the propensity to advert freely that which you may find in the work of others.

Your article is excellent, so much more so because it is entirely objective. It is only in the sustained and passionate impulse of the analysis that one may sense your affection and marvelous spirit of comradeship toward me, without permitting your sentiment to influence for one moment your clear and certain technical judgment.

Many thanks, dear friend of mine,

DIEGO RIVERA

ACKNOWLEDGMENTS

This book directs attention to the fundamental and extensive training that gave impulse to the philosophy of the man and the evolution of the artist Diego Rivera—from his earliest studies through his independent work in Mexico and in Europe—up to and including part of the year 1921. I hope that the significance of this early background—which was to define Rivera's later painting—may effect a sympathetic understanding of the artist's dedication, love for his country, and contribution to the art of his time.

I am indebted to friends and institutions in the United States and in Mexico for encouragement and invaluable assistance in acquiring photographs and documentation. I wish to express my appreciation to Daniel Catton Rich, Director of the Worcester Museum of Art, Worcester, Massachusetts, for his kindness in reading the original manuscript as well as for his constructive criticism. I wish also to thank Kathleen Blackshear, formerly of the School of the Art Institute of Chicago (now retired), for her suggestions and encouragement.

In Mexico, I am grateful to the distinguished photographer Guillermo Zamora for his generous co-operation in contributing photographs of Rivera's early and less-well-known works and of others from later periods; to the National Institute of Fine Arts for permission to select additional photographs from its extensive and well-documented archives; to Daniel Rubin de la Borbolla, Director of the Museum of Popular Arts, for sharing his recollections of experiences and discussions with Rivera and for his generosity in contributing rare photographs of Rivera's work as well as those of indigenous folk arts; to Inés Amor, Director of the Gallery of Mexican Art and one of the first to sponsor the work of then obscure artists (including Diego Rivera, José Clemente Orozco, and David Alfaro Siqueiros), who generously provided photographs of early and little-known paintings and drawings by Rivera; to Dr. Mario Gonzalez-Ulloa for his sustained interest; and,

finally, to A. Curtis and Karna Witgus and the late Frederick W. Davis, whose warm friendship through the years and enthusiastic encouragement have contributed much to this book and to me as an individual.

CONTENTS

ILLUSTRATIONS

BLACK-AND-WHITE PLATES

DIEGO RIVERA

DIEGO RIVERA'S CREED

Why are the prophets stoned? Take patience, [Diego], . . . you will die. Your thought will be voiced tomorrow clearer than it is today, for the dwarfs will stop their bellows. This wall will witness comical scenes, lay processions guide books in hand, gaping in awe at the "Old Master." . . . You will be well haloed, subjected to political speeches and art historians. Meanwhile, pursue your task. You have enough wit to manoeuver your heavy shell, enough philosophy to be flippant.[1]

These were the words of Jean Charlot, in March, 1923, upon the completion of one of Diego Rivera's early murals. With characteristic energy and humor Rivera throughout his life did just this—and the prophecy long since has come to pass.

In 1957, in the National Palace of Fine Arts, Mexico paid her final tribute to Diego Rivera.[2] As early as 1921, Diego Rivera, José Clemente Orozco—Mexico's twin giants of their day—and David Alfaro Siqueiros had already been identified with the phenomenal revival of mural painting and fresco technique. By their work these three artists gave powerful momentum to the new concept of murals as a politico-social tool. In so doing, they created the base for the far-reaching movement which has since been described as the renaissance in Mexican art.[3]

Of the three artists only Siqueiros is living today. Current evaluation suggests that Rivera's role in this renaissance might be likened to that of a proud historian who contributed a romantic documentation of his beloved country: its rich indigenous Indian past, its exciting and portentous present, and his own dreams and aspirations for its future. In contrast, Orozco was the tragic poet of Mexico.

Diego Rivera has stated his creed:

To be an artist, one must first be a man, vitally concerned with all problems of social struggle, unflinching in portraying them without concealment or evasion, never shirking the truth as he understands it,

never withdrawing from life. As a painter, his problems are those of his craft. He is a workman and an artisan. As an artist, he must be a dreamer; he must interpret the unexpressed hopes, fears, and desires of his people and of his time; he must be the conscience of his culture. His work must contain the whole substance of morality, not in content, but rather by the sheer force of its aesthetic facts.[4]

Dedicated as Rivera was in his adherence to this concept of the role of the artist in the social structure of his society, his career could be only a stormy one, for inherently it constituted a challenge to himself and to his audience. He expected to raise controversial issues, and, because of his own aroused conscience, compassion, and hatred of smugness and deceit, he occasionally did so deliberately. He was therefore neither surprised nor truly distressed when unpleasant situations developed. Now and then he may have seemed abusive, or even brutal, in his painting, but even his most scathing work was always eloquent and never designed to offend or humiliate the masses for whom his work was primarily intended. Rather, his shrewd, concise statements tended to stimulate and intensify understanding. Nevertheless, bitter controversies did arise and sometimes became so violent that his life and his works were threatened.[5] Some of his murals were destroyed, and others were mutilated.[6] Rivera felt that all such controversies were helpful, however, in that they tended to focus attention upon particular conditions or aspects of society which might jeopardize progress toward a better social order. As a result, he was perhaps victimized by unfortunate publicity which emphasized political content and social significance and ignored the true aesthetic values inherent in his work.

During one such controversy, in Detroit in 1932, Diego Rivera wrote:

> If my Detroit murals are destroyed I shall be profoundly distressed, as I put into them a year of my life and the best of my talent, but tomorrow I shall be busy making others for I am not merely an artist, but a man performing his biological function of producing paintings just as a tree produces flowers and fruit, nor mourns their loss each year, knowing that the next season it shall blossom and bear fruit again.[7]

This statement is of the utmost significance in understanding the man and the artist, for it reveals his own recognition and acceptance of the fact that his very existence was in this specific relationship to painting. Although politics was always a consuming passion for Rivera, his painting was never truly or consistently subordinated to his political enthusiasms. These enthusiasms may have varied from time to time, with changing conditions and changing sympathies, but his unswerving fidelity to his own ideals as expressed in his work remained the solid, unyielding core around which his life as an artist developed.

Communism held a theoretical, intellectual, and emotional appeal for Rivera, probably stimulated by his early happy associations with young Russians and other revolutionaries in Paris. Then, too, he liked to think of himself as a radical. Nevertheless, he was a dissident and critical member of the Communist party—in 1929 he was expelled. For the following twenty-five years he remained independent of all such formal affiliations. In 1954, shortly before his death, he permitted himself to be reinstated in the party:

In need of names to brighten its roster, Mexico's short-handed (membership barely 5,000) Communist Party offered a bittersweet welcome to long-lost comrade Diego Rivera, 67. In 1929 Comrade Rivera was ex-communicated because of his growing list of deviations. . . . Back in the fold again last week, Rivera was strangely mum. In tragic truth, he was tired, in bad health and grieving over the recent death of his wife [Frida Kahlo].[8]

NOTES FOR CHAPTER I

[1] Jean Charlot, *Art from the Maya to Walt Disney*, 1.

[2] Rivera died in his studio at San Angel during the night of November 24, 1957.

[3] This movement was to exert a marked influence not only upon the art of those other Latin American nations in which strong indigenous Indian cultures and traditions still existed but also upon painting in the United States. Murals in fresco and other techniques, painted during the 1930's on the walls of public, tax-maintained institutions under the sponsorship of the WPA Art Project, are clear evidence of this influence. Also attributable to the same source was the rise of a school of social significance in painting. More directly, Mexican masters like Orozco and Rivera were invited to the United States to paint frescoes, and many North American artists visited and studied in Mexico—a practice that still continues.

[4] A summary of written and verbal statements to the author and others.

[5] At times he wore a pistol while he worked in public (*Chicago Daily Tribune*, November 26, 1957, and personal conversations with Rivera).

[6] The Rockefeller Center murals, painted in 1933, were completely destroyed. A section of the mural painted in 1929 for the stairway of the National Palace in Mexico City—the section critical of the role of some of the clergy before the revolution—was defaced but was later restored. Four large panels of the Hotel Reforma frescoes painted in 1936 were removed and are now in the Gallery of Mexican Art in Mexico City. Sections of the 1947-48 frescoes in the dining room of the Prado Hotel were defaced. The entire work was later boarded up for "protective custody" after restoration and a national scandal. The controversial sections are now changed, and the mural is again available for viewing. The 1951 fresco for the National Palace of Fine Arts, planned for international exhibitions in Europe, was rejected and "held in custody" by the authorities.

[7] "Dynamic Detroit: An Interpretation," *Creative Arts,* April, 1933, 295. The Detroit murals were neither destroyed nor defaced.

[8] *Time*, October 11, 1954, 50.

THE FORMATIVE YEARS,
1889-1902

Diego Rivera and a short-lived twin brother were born in Guanajuato, Mexico, on December 8, 1886.[1] His parents, María de Pilar Barrientos Rivera and Diego Rivera, a mining chemist, rural schoolteacher, city councilor, and editor of the local liberal newspaper, *El Demócrata*, had their son christened Diego María de la Concepción Juan Nepomuceno Estanislao de la Rivera y Barrientos Acosta y Rodríguez.[2]

At the time of Diego's birth Guanajuato was a declining city. Despite its former fame as an affluent mining center, by the end of the nineteenth century many of the mines had been closed and a sharp decrease in population had resulted. Those who had remained faced unemployment and great need. Through his paper Diego's father, a dedicated liberal, stressed the hardships of the troubled workers, expressed their desires, and concerned himself with the solution of their many problems. It was only natural that Diego the son, in his formative years, heard discussions of these perplexing issues. As an adult, he not only claimed to remember those discussions vividly but also acknowledged the influence of his father's convictions in the shaping of his own. Certainly Diego's acute and continued awareness of social problems and his sympathy for the wronged and the underprivileged may be attributed to this background. "Diego Rivera heard his father express his opinions and became a rebel from the time he was a baby."[3]

Diego Rivera spent the first six years of his life in Guanajuato. By the time he was little more than three, he was making sketches of the world about him. "One of my earliest memories of my youth is that I was always drawing." From that period comes his impression of a train, including locomotive and caboose (Plate 6).

In 1892 the family moved to Mexico City. Five years later Diego was enrolled in the San Carlos Academy of Fine Arts, where he began the formal study of art. For about two years he attended classes at night. In 1899 he was awarded a scholarship that

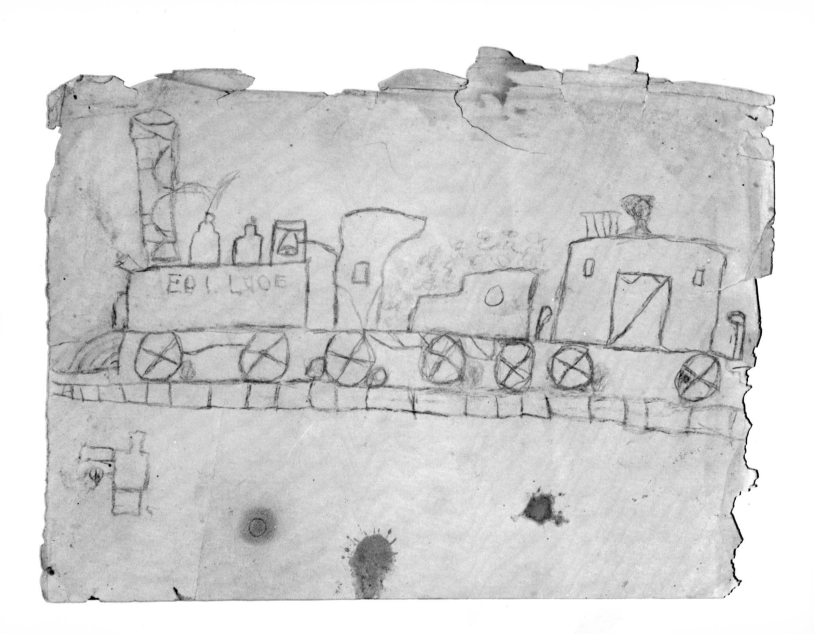

enabled him to enroll as a full-time student in the regular daytime classes.

The San Carlos Academy had been founded by Spanish royal decree in 1785, supplanting the earlier School of Engraving, which had been established in 1778. Similar academies had been established at about the same time in Buenos Aires, Santiago de Chile, and Havana and by the Portuguese in Rio de Janeiro.

All these institutions had remained strongholds of "official" art. Many of the instructors were European, preferably French or at least trained in France. The styles and techniques paralleled the established precedents of European academicism and neoclassicism. It was to the rigid discipline intrinsic in his early training that Rivera was largely indebted for his superb draftsmanship. In addition, the stimulating influence of three of his instructors not only contributed to the development of his personal style

Plate 6. The Train, by Diego Rivera. Pencil drawing, 1889. Collection of Frida Kahlo Memorial Museum, Coyoacán.

and technical proficiency in painting but also encouraged interests which were later to become major forces in his life and work.

One of these teachers was Santiago Rebull (1829–1902), a former student of the French neoclassicist Jean Ingres. Because of Ingres's skill as a draftsman and the elegance of his superbly controlled line, he has been described as "one of the greatest portraitists of occidental art."[4] Ingres insisted that "an object well drawn is always well enough painted,"[5] and Rebull stressed this doctrine in his own teaching. Consequently, Rivera soon acquired great skill in drawing. In 1898, at the age of twelve and in his second year at San Carlos, he produced *Head of a Woman* (Plate 7), a pencil drawing on tinted paper. In the drawing Rivera, by his masterly use of line and of tonal values in shading, not only created a sensitive interpretation of his model but also displayed a virtuosity and maturity rarely achieved by so young an artist.

Rebull also endowed his student with a particularly pertinent attitude toward his work. He explained: "You are interested in movement and living things. . . . The things that we call painting and draw-

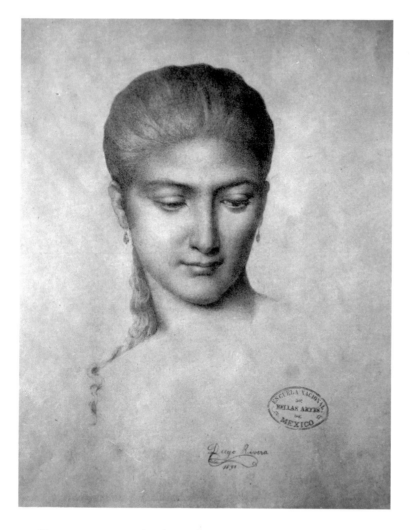

ing are nothing but attempts to write out upon a flat surface what actually exists in the movements of life.">[6]

A second influence on Rivera—and one of great potential significance—was that of Felix Parra, an academic painter who, despite the limitations imposed by his own training, nevertheless recognized the particular and special qualities of Mexico's pre-Hispanic art and architecture. Parra's enthusiasm was transferred to his student, and may have subsequently given impetus to Rivera's own rediscovery of and dedication to that great era of Mexico's past.

Felix Parra supplemented Rivera's academic training in drawing with similar instruction in painting. The teacher adhered to the traditional practice of using plaster casts of classical sculpture as models —a European technique reaffirmed and stressed by Antonio Fabrés, appointed director of the San Carlos Academy in 1902. Students were required to spend

Plate 7. Head of a Woman, by Diego Rivera. Pencil drawing, 1898, 36.5 x 28.3 cm. Collection of National Institute of Fine Arts, Mexico City. Photograph by José Verde O.

long, uninspired hours in the tedious exercise of copying these subjects as accurately and realistically as possible. In his autobiography José Clemente Orozco, who, like Rivera, was a student at San Carlos, described the method:

> Fabrés's teaching followed the intense rigid discipline as practiced in the academies of Europe. . . . One slaved to copy photographic naturalism with the greatest exactness—no matter how much time or effort was required to do so. The same models, in the same positions, remained in front of students for weeks and even months without any change.[7]

How well young Rivera absorbed that training is evidenced in *Saint Peter* (Plate 8), an academic study in oil on canvas, dated 1902. In this work his basic understanding of sculptural form and his technical skill in representing it through meticulous and subtle modeling achieve such convincing realism that a black-and-white photograph of the canvas creates the illusion of a photograph of the original sculpture. In his autobiography Orozco wrote, "When students had completed the copying of the model, . . . a photographer took a picture of the model so that students might compare their work with the photograph."[8]

The most admired and emulated among Diego Rivera's instructors at San Carlos Academy was José María Velasco (1840–1912)—the "great man," as Diego usually referred to him—who has been called the "finest landscapist the Western hemisphere has produced."[9] Velasco, also a former student at the academy, had been appointed professor of landscape perspective in 1868. Despite his contact with new movements in painting during official visits to Europe and the United States, where he participated in exhibitions, Velasco continued to paint as a romantic realist throughout his career. His favorite subject seems to have been the Valley of Mexico (Plate 9), which he interpreted in its many aspects and moods, employing both color and linear perspective to create the illusion of great distances. Only in 1942 did Velasco gain official recognition. In that year, at the conclusion of a highly successful and popular retrospective exhibition at the National Palace of Fine Arts in Mexico City, his works were by presidential decree declared "national monuments"—an honor

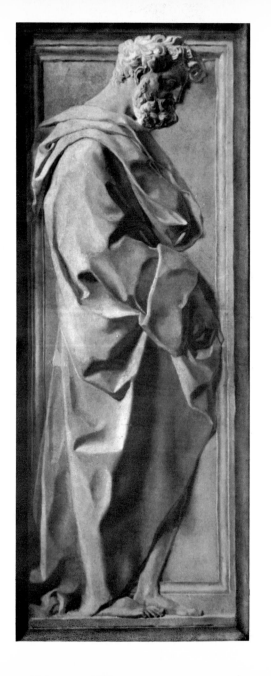

now shared with the works of two of his former students, Orozco and Rivera.

The contemporary Mexican poet Carlos Pellicer, in paying tribute to Velasco, has said:

> The Valley of Mexico is one of the major phenomena in the history of our planet. At an altitude of seven and a half thousand feet above sea level, its enormous area has been the theatre of vast and manifold geological dramas. . . .
> Light there is cold and pure and upon its surfaces heaven and earth have written in a fine hand. . . . It has a clarity made up of greys, paling to blue and deepening to black. . . . This is what Maestro José María Velasco drew and painted. He was a man of genius, the greatest artist Mexico produced.[10]

It may be that Velasco's most distinct and enduring service to the young Rivera was his own profound love for and eloquent interpretation of his

Plate 8. Saint Peter, by Diego Rivera. Oil on canvas, 1902, 1.120 x 0.525 m. Collection of Frida Kahlo Memorial Museum, Coyoacán. Photograph by José Verde O.

native Mexico, as expressed in his magnificent panoramic landscapes (Plate 10). Implicit in the paintings is the new spirit of nationalism which characterized Latin American art of that period. The heroic mood embodied a new concern with everyday subjects, a new attitude toward nature, and a re-evaluation of the local and regional scene in terms of a consciously romantic yet essentially realistic and intellectual interpretation.[11] To realistic content Velasco added strong, effective composition. Technically the movement was marked by a return to a palette of rich color, freedom and directness in brush-work, and the subordination—if not actual elimination—of severe, incisive line.

It was from Velasco that Diego Rivera acquired his basic understanding of structure and composition in painting, and it was Velasco whom he acknowledged as his mentor when he began his career as an independent artist.[12]

But it was the printmaker José Guadalupe Posada (1852–1913) who was to become the major influence on the philosophy and development of Diego Rivera the artist and the man. By auspicious if not prophetic coincidence, Posada's "stronghold"

was a "humble workshop, installed in the carriage entrance at the side of the Church of Santa Inés, and the San Carlos Academy of Fine Arts."[13] There "Posada would work in public view behind a glass window that faced the street."[14]

The prints on display in Posada's workshop and the artist himself were irresistible magnets which drew Rivera and fellow students, including Orozco, to the spot. Both Rivera and Orozco described themselves as "charmed." Orozco said:

> I used to stop for a few minutes on my way to school to gaze at the engraver. This was four times each day . . . going to and coming from classes, and sometimes I dared to enter the shop to steal a little of the metal shavings which were formed when the artist's burin ran over the vermillion-painted metal printing plate. This was the first stimulus to awaken my imagination . . . the first revelation of the art of painting. . . .
>
> In the same shop Posada's engravings were illuminated by hand with a stenciler, and when I observed this operation I received my first lesson in painting.[15]

Rivera, too, absorbed lessons from Posada as he

13

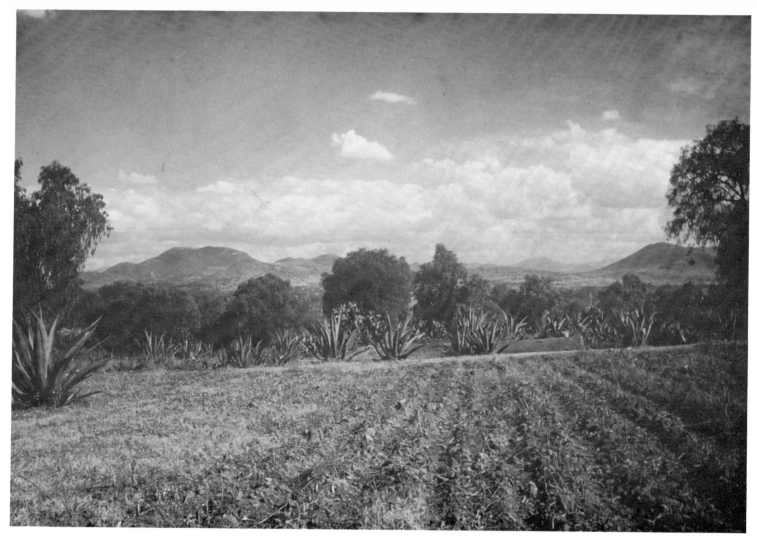

Plate 9. The Valley of Mexico, 1941. Photograph by Florence Arquin.

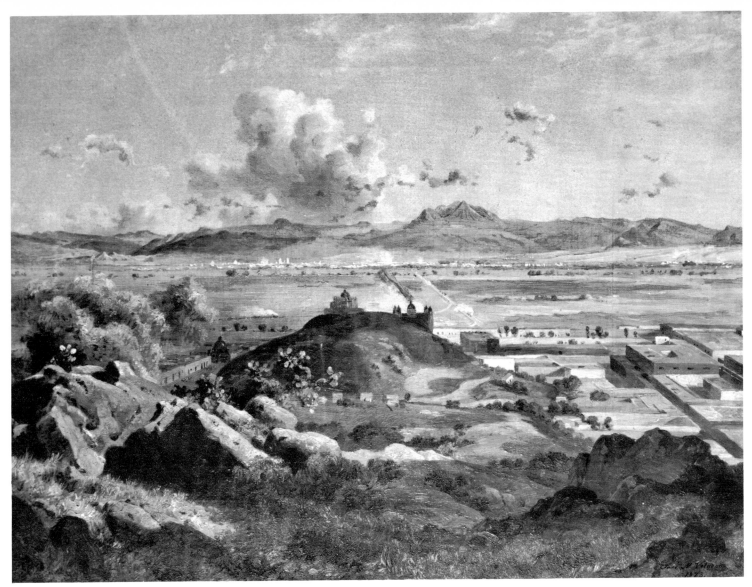

Plate 10. Valley of Mexico from Guadalupe, *by José María Velasco. Oil on canvas, 1873. Courtesy of National Institute of Fine Arts, Mexico City. Photograph by José Verde O.*

returned day after day to stand in rapt concentration before the window. Later, discussing this vividly recalled experience, Rivera reminisced about the excitement and delight that accompanied his awareness of Posada's interest in him and about the first invitation he received to enter the workshop. In the course of succeeding and frequent visits, the printmaker and the student became close friends.[16]

It was a most fortunate association. In his work, philosophy, and discussions with the impressionable young Diego Rivera, Posada counteracted the restraining influences of the school of Ingres as taught at the academy. Less directly, but no less effectively, Posada inculcated his own liberal political ideas, for he strongly opposed in both word and art the oppressive dictatorship of Porfirio Díaz. Diego Rivera assimilated this newly acquired political awareness and later used it in his own painting. Throughout his life Rivera affectionately called Posada "my teacher" and often expressed reverence for the man whose influence in those formative years proved so important and lasting. The association with Posada served further to develop Diego's already marked skill in drawing and his lasting preference for tense, vigorous

line and unequivocal statement and to crystallize his understanding of precise, balanced interrelationships of light and dark and of movement in composition.

Posada, through his mordant line, biting humor, and dramatic representation in black-and-white engravings, has gained recognition as Mexico's greatest printmaker. Of equal significance is the fact that he also represented an early independent movement in the evolution of contemporary Mexican art, for he was one of the first, in those turbulent days, to draw inspiration from Mexican social issues. Although official recognition came only after he had been dead for many years, he was the most popular satirist of his day, as closely associated with Mexico as Francisco Goya is with Spain or Honoré Daumier with France. He made very personal use of the *calavera*—the human skull and, by implication, the whole skeleton (Plate 11).[17] The great popular appeal of the form stems from Posada's deep understanding of Mexican humor and irony—which includes jesting with death—and from an equally profound understanding of traditional popular Mexican taste, which widely accepted the *calavera* and its implications (Plate 12). Posada's derisive, gleeful

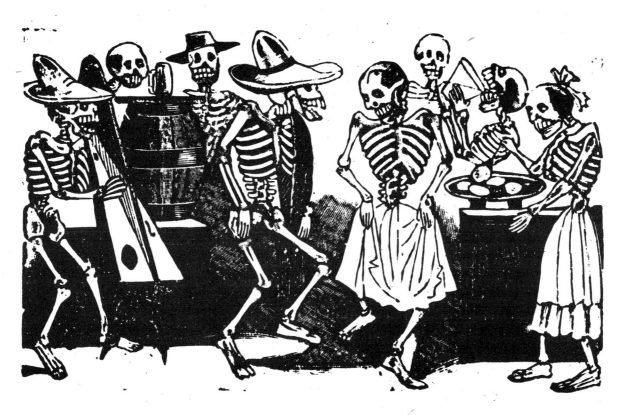

Plate 11. A Jig Beyond the Grave, *by José Guadalupe Posada. Engraving, between* 1890 *and* 1900. *Courtesy of National Institute of Fine Arts, Mexico City. Photograph by José Verde O.*

calaveras (Plate 13) were seen as the common denominator of all mankind and as symbols of biological equality, and became a direct allusion to the desire for political and social equality. In modern times, with changing and improved conditions, the connotation of the *calavera* has been expanded to include new and equally pertinent commentary on existing aspects of the economic, political, and social scenes (Plate 14).[18]

The persistence of this popular form of expression is seen today in handbills, still called *calaveras*, celebrating the Day of the Dead and sold in the streets of many Mexican cities and smaller communities (Plate 19). True to tradition, the handbills are devoted to caricatures as well as satirical comment addressed to prominent individuals in public life.[19]

Posada's broadsides, issued in huge editions by the publishing house of Vanegas Arroyo, were designed primarily to meet the specific needs of the large illiterate segment of the population. In effect, and for that group in particular, the estimated fifteen thousand engravings made by Posada before his death were the newspapers of the period.[20] Conse-

quently, anything that might interest his large audience became a theme for Posada's art. His illustrations were necessarily forceful and pertinent, and they were accompanied by equally dramatic comments in verse. These literary graphic prints have since been described as forming "an intimate gallery of the standards and attitudes of the petit-bourgeois and city-artisan class of the nineteenth and early twentieth century, to which Posada . . . belonged."[21]

Within the wide range of Posada's subjects were humorous as well as scathing interpretations of current events, particularly those of political or social implication. In review, these particular prints assume major importance because it has been recognized that "Posada, through the medium of his work, was one of those actively responsible in preparing the way for the 1910 revolution. In his engravings, an inarticulate public protest found its just expression."[22]

Diego Rivera, fully aware of the role Posada played in his own development, said, "Posada taught me the connection between life and art—that you cannot paint what you do not feel."[23] From the vivid memories of personal observations and the rapport established between friends and fellow artists, Rivera

(*Text continues on page 22.*)

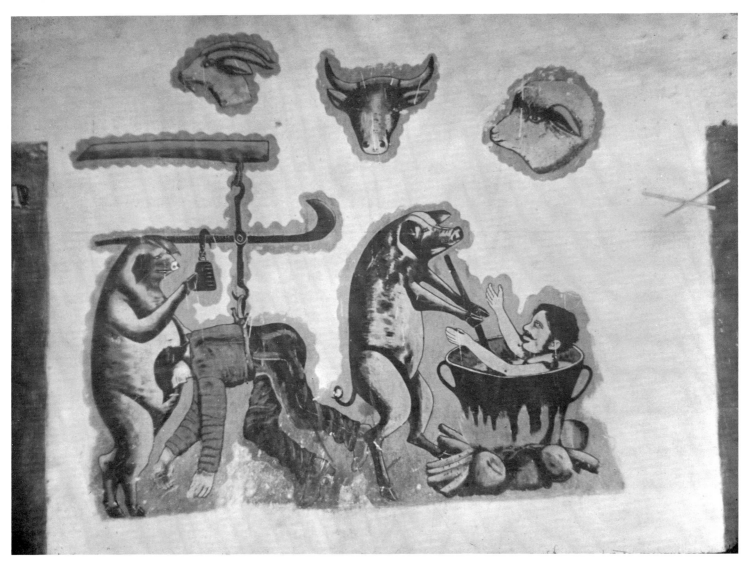

Plate 12. Surrealist popular fresco on plaster wall of a butcher shop near Teotihuacán, Mexico. Photograph by Florence Arquin, 1956.

Plate 14. Skulls and Skeletons of Artisans, *by José Guadalupe Posada. Relief engraving, hand-colored, printed on handbill between 1910 and 1913. Courtesy of The Art Institute of Chicago, Collection of William McCallin McKee.*

Plate 13. Calavera Catrina (*also known as* Irony, Death Head of an Idler, *and* Calavera of the Female Dandy), *by José Guadalupe Posada. Engraving, ca. 1900, 4 5/16 x 6 1/8 in. Courtesy of National Institute of Fine Arts, Mexico City. Photograph by José Verde O.*

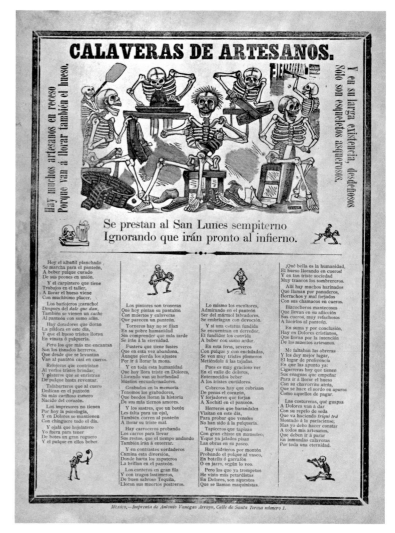

analyzed the attributes and contributions of the work of Posada and unconsciously suggested a parallel analysis of his own work and contribution:

> Analyzing the work of Posada, a complete understanding of the social life of the Mexican people may be achieved. . . . Posada, interpreter of the sorrows, the happiness and the anguished aspirations of the Mexican people; . . . illustrator of stories, legends, songs, and prayers of the people; . . . a tenacious, mocking, and ferocious combatant; Posada, so integrated with the popular soul of Mexico that perhaps his identity will become completely lost. But today his work and his life penetrate . . . into the views of the young Mexican artists. . . .
> The plastic values of Posada's work are the most essential and the most permanent. . . . Posada's composition, which is strangely dynamic, maintains the greatest equilibrium of chiaroscuro in relation to the division of the engraving. . . . Equilibrium, as

(*Text continues on page 29.*)

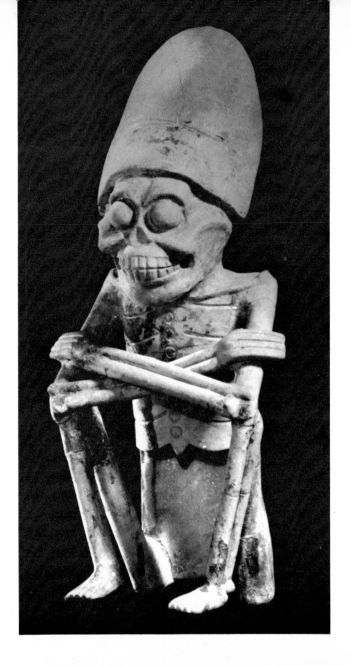

Plate 16. Clay figure denoting Death, Remojadas, Veracruz, Mexico. Represents culture of the Gulf area. Courtesy of National Institute of Anthropology and History, Mexico City.

Plate 17. (*below*) Mictecacihuatl, *Aztec Goddess of Death, wearing crown of skulls and collar of hands and skulls. Courtesy of National Institute of Anthropology and History, Mexico City.*

Plate 18. (*right*) Coatlicue, *Aztec Goddess of the Earth. The head is formed by the heads of two serpents, the skirt of braided serpents, and the collar of human hands and hearts, from which hangs a human head.* 2.6 m. *Courtesy of National Institute of Anthropology and History, Mexico City.*

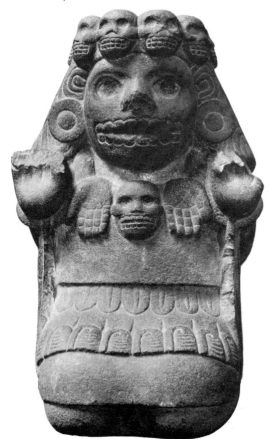

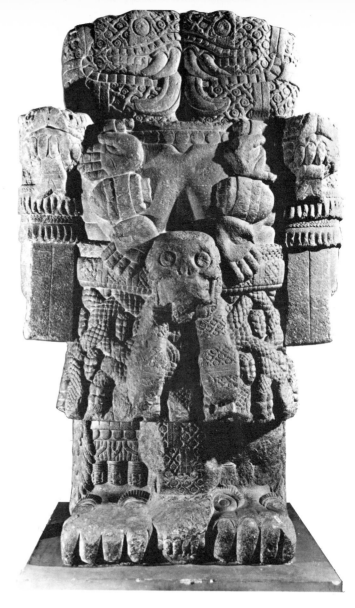

23

Plate 19. La Madre Mariana, *handbill celebrating the Day of the Dead (November 1–2), ca. 1960. Courtesy of The Art Institute of Chicago.*

Plate 20. Candelabra, *artist unknown.*
Painted clay, 24 in. Courtesy of National
Museum of Popular Arts and Crafts, Mexi-
co City.

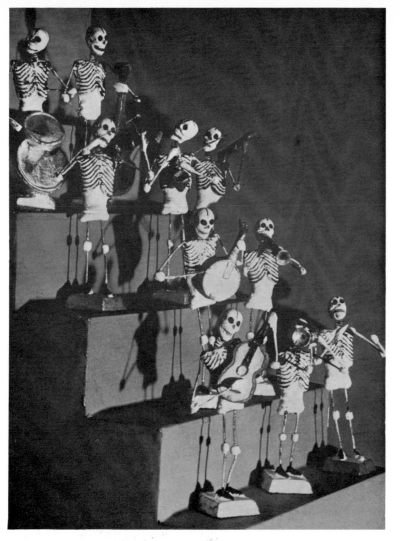

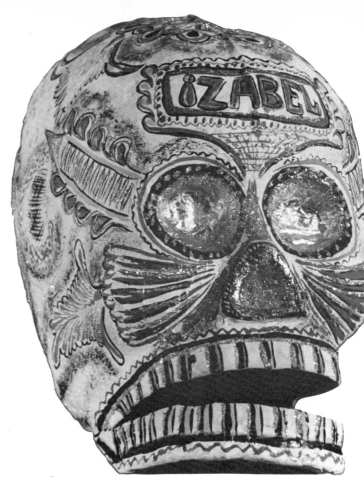

Plate 21. Musicians, *artist unknown. Painted clay, about 8 in. Courtesy of National Museum of Popular Arts and Crafts, Mexico City.*

Plate 22. Skull, *artist unknown. Painted papier-mâché, 12 in. Courtesy of National Museum of Popular Arts and Crafts, Mexico City.*

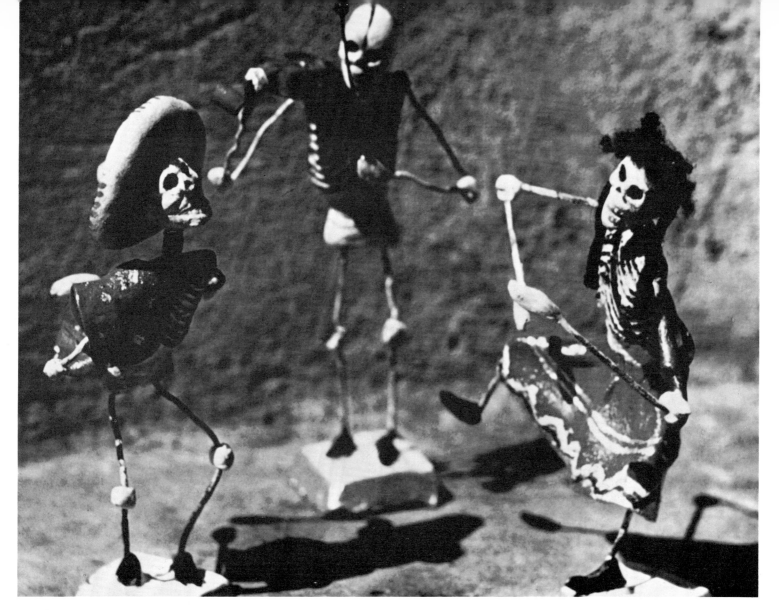

Plate 23. Death Plays a Tune for the Dancers, *artist unknown. Plaster and wire, 6 in. Courtesy of National Museum of Popular Arts and Crafts, Mexico City.*

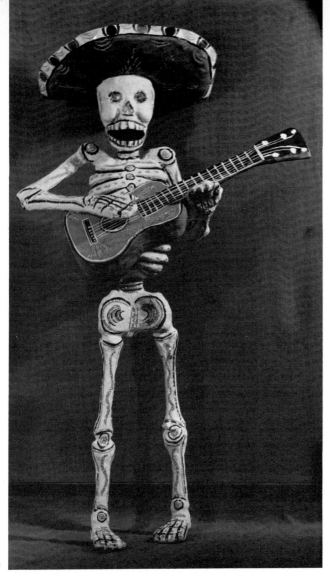

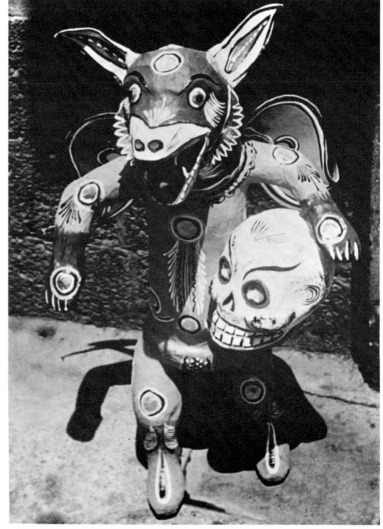

Plate 25. Judas with Calavera, *artist unknown. Painted papier-mâché, about 3 ft. Photograph by Florence Arquin.*

Plate 24. Musician, *artist unknown. Painted papier-mâché, 18 to 20 in. Courtesy of National Museum of Popular Arts and Crafts, Mexico City.*

much as movement is the greatest quality . . . of pre-Conquest art. . . . Because Posada was a classic, photographic reality never subjugated him. He always knew how to express plastic values. . . . The distribution of black and white, the inflection of line, proportion, all in Posada is his own and because of this, he ranks among the greatest.

His sharp graver spared neither the rich nor the poor. To the latter he showed their weaknesses, with sympathy, and to the others he threw into their faces the vitriol that bit the metal on which he created his work.

If what Auguste Renoir said is indisputable, that a work of art is characterized by being inimitable and indefinable, we can affirm that the work of Posada is a work par excellence. No one will imitate Posada; no one will define Posada. His work, because of its form, comprehends all plastic, and because of its content, comprehends all of life, things too great to be enclosed within the miserable limits of a definition.[24]

NOTES FOR CHAPTER II

1 The house in which he was born, at Calle Pocitos 80, is now marked by a commemorative plaque, placed there on the artist's seventieth birthday.

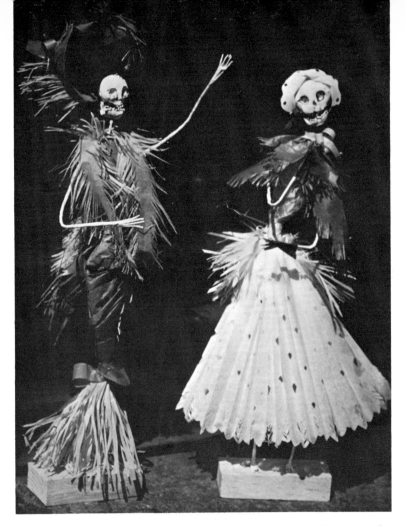

Plate 26. Day of the Dead, artist unknown. Satirical criticism in the tradition of Posada. Wire and painted papier-mâché, 8 to 10 in. Courtesy of National Museum of Popular Arts and Crafts, Mexico City. Photograph by Florence Arquin.

[2] Ronald Hilton (ed.), *Who's Who in Latin America*.

[3] Frances Toor, *Twelve Reproductions in Color of Mexican Frescoes by Diego Rivera*, 1.

[4] Dagobert D. Runes and Harry G. Schrickel (eds.), *Encyclopedia of the Arts*, 368.

[5] John Rewald, *A History of Impressionism*, 18.

[6] *Diego Rivera*, Catalogue, November 15–December 25, 1930, San Francisco, California Palace of the Legion of Honor.

[7] José Clemente Orozco, *Autobiography*, 114.

[8] *Ibid.*, 114.

[9] Henry Clifford, "Notes on Velasco's Paintings," *Catalogue*, Philadelphia Centennial Exhibition, 1944–1945, Philadelphia Museum of Art, 15.

[10] Carlos Pellicer, "The Valley of Mexico," *Mexico City News*, December 20, 1958.

[11] Although different in spirit, a precedent for painting such environmental and regional subjects had been established in Brazil in the seventeenth century by the Dutch artist Frans Post, of Leyden, during his country's occupation of the Pernambuco area in 1637–44. Post was one of a group of artists, architects, and other professionals selected to accompany the first governor appointed to the newly acquired Dutch possession in Brazil. Post's highly styled and meticulously painted canvases record the topographic aspects of the local scene, as well as characteristic features of plantation life in the area. They have since been described as the first landscapes of America by the first American landscape painter (Robert C. Smith, "Three Brazilian Landscapes of Frans Post," *Arts Quarterly* [Detroit Institute of Arts], Vol. I [1938], 246).

[12] Conversation with Rivera.

[13] Diego Rivera, "José Guadalupe Posada: A Magisterial Utilization of Clean Bones," *Massachusetts Review*, Vol. III, No. 2 (reprint).

[14] José Clemente Orozco, "The Stimulus of Posada," *Massachusetts Review*, Vol. III, No. 2 (reprint).

[15] *Ibid.*

[16] Conversation with Rivera.

[17] Posada was not the first Mexican artist to use these symbols. He had been preceded by the lithographer Santiago Hernandez (1883–1903) and by the engraver Manuel Manilla (d. 1895).

[18] Established precedent for the use of the skull and skeleton as plastic elements can be found in the painting, sculpture, and ceramics of pre-Conquest Mexico (Plates 15–18).

[19] Other art forms typical of those produced for the Day of the Dead celebrations are shown in Plates 20–26.

[20] Alfred H. Barr, Jr. (ed.), *Masters of Modern Art*, 11.

[21] José Guadalupe Posada, *100 Original Woodcuts by Posada*.

[22] Fernando Gamboa, *Posada: Printmaker of the Mexican People*, intro.

[23] Conversation with Rivera.

[24] Diego Rivera, "The Work of José Guadalupe Posada, Mexican Engraver," *Mexican Folkways*, 1930, intro.

INDEPENDENT WORK IN MEXICO, 1902-1907

The year 1902 was an early and decisive turning point in Diego Rivera's career. Illness had forced the popular teacher Velasco to resign from his post at the academy. The new director, the academic Spanish painter Antonio Fabrés, immediately initiated a return to photographic realism as the school's mandatory and official goal.

In the same year a students' strike was organized and led by the already politically minded young Rivera to protest the re-election of President Díaz. As a result Rivera and his companions were temporarily expelled from the school. Rivera refused to return and determined instead to begin his first independent work as an artist. Here was the opportunity to explore and paint the countryside, to work in a studio of his own, and to experiment.[1]

The painting *Saint Peter* is of particular im-

portance in that it exemplifies the inflexible discipline of the academy while demonstrating Rivera's own skill and virtuosity in this significant period. It may be interpreted as representing the conclusion of a preliminary period of training, after which the artist began his search for a personal, free, self-directed expression.

A development in that direction is indicated in the landscape *The Chestnut Grove*, painted in 1904 (Plate 27). Here the organization of composition in terms of linear perspective shows the obvious influence of the work of his former teacher. Rivera used converging rows of dark trees to frame the area of highest color values, create sharp contrast, focus attention upon background, and so reinforce the illusion of depth established by perspective. In addition, the canvas shows an independent interpretation of subject, as well as freedom in the use of the medium. Drawing has already appeared as a fundamental and distinctive element, one which will become an identi-

Plate 27. The Chestnut Grove, by Diego Rivera. Oil on canvas, 1904. Collection of Franz Mayer, Mexico City. Courtesy of National Institute of Fine Arts, Mexico City. Photograph by José Verde O.

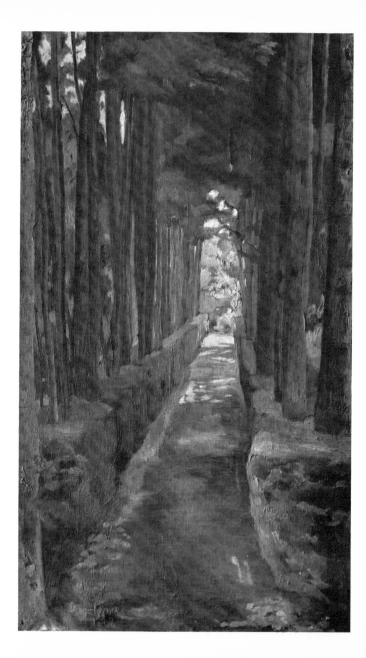

fying characteristic of his later work. Rivera was fully aware of his special gift for drawing, which he enjoyed even more than he did painting. Shortly before his death he said to me, "I want you to have one of my drawings because they are much better than my paintings."

Similar only in independence of expression is *The Threshing Floor*, also painted in 1904 (Plate 28). This canvas, like others of the period, is somewhat reminiscent of the work of Velasco and at the same time shows the continuing influence of Rivera's early academic training. Certain new elements now appear, however. A deliberate and crisp definition of form brings modern photography to mind, and a new kind of realism incorporates storytelling. This quality of romantic, literary realism would become a distinctive feature of Rivera's work after 1921, when he would revert to the use of thin paint, applied to smooth canvas with small, smooth brushstrokes. As late as 1947, when Rivera was painting the mural for the Hotel Del Prado, in Mexico City, he and I discussed the merits of this technique, which he still preferred, as opposed to the emphasis on texture resulting from heavy application of pigment. Rivera

commented, "Texture is the modern artist's excuse for lack of talent!"

In 1906, Rivera painted the landscape *Ravine at Mixcoac* (Plate 29). The asymmetrical composition, sound structure, technique, and style are again reminiscent of Velasco (Plate 30) and, indirectly, of Gustave Courbet (1819–77). Rivera's early training in interpreting visual reality in terms of romantic realism prepared him for impressionism and its fundamental problem–the spontaneous representation of color in terms of fleeting and ever-changing effects of light. Rivera's interest in impressionism at the time stemmed from his friendship with Dr. Atl (pseudonym of Gerardo Murillo), who had returned from Europe in 1902 and had soon become a dynamic and forceful leader of the younger Mexican artists.[2] Dr. Atl's convictions directly affected those of both Rivera and Orozco, who were still studying at the San Carlos Academy, where Dr. Atl had a studio and assisted in the evening drawing and painting classes. An indomitable rebel, Dr. Atl was one of the first to stress the need for a national Mexican art rooted in its indigenous cultural heritage. His political and social theories not only incorporated an

(*Text continues on page 37.*) 33

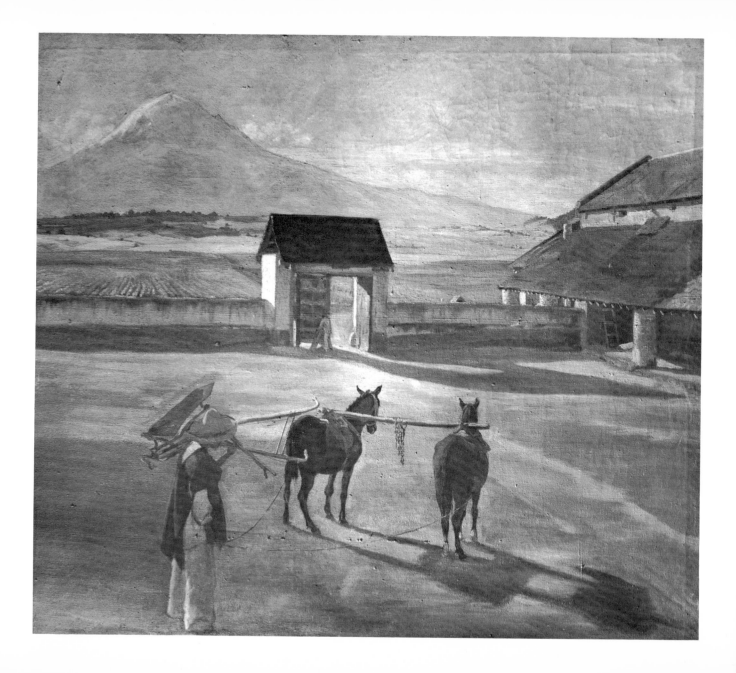

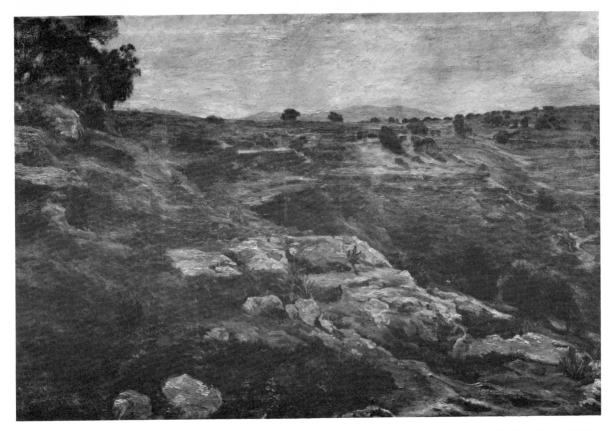

Plate 29. Ravine at Mixcoac, *by Diego Rivera. Oil on canvas, 1906, 0.70 x 0.953 m. Collection of Mrs. Diego Rivera's Gallery, Mexico City. Courtesy of National Institute of Fine Arts, Mexico City. Photograph by José Verde O.*

Plate 28. (left) The Threshing Floor (*also known as* La Era), *by Diego Rivera. Oil on canvas, 1904, 1.00 x 1.145 m. Collection of Marte R. Gómez, Mexico City. Courtesy of National Institute of Fine Arts, Mexico City. Photograph by José Verde O.*

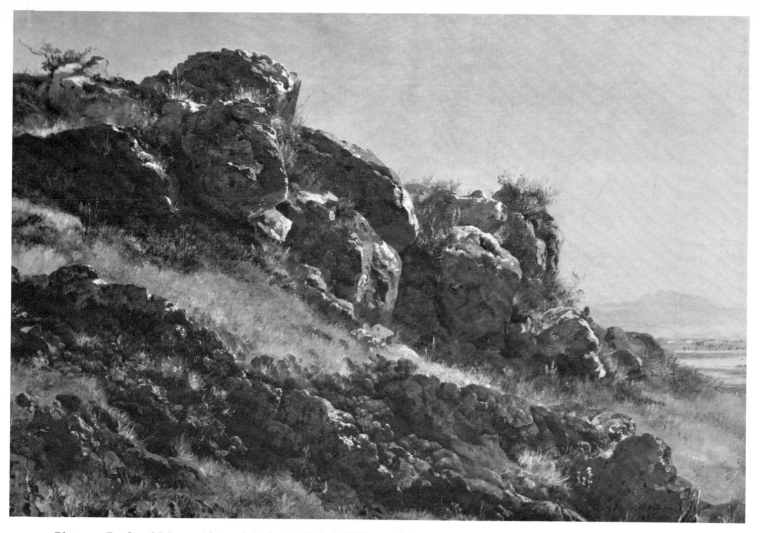

Plate 30. Rocks of Monte Alzacoalco, *by José María Velasco. Oil on canvas, 1875. Collection of National Institute of Fine Arts, Mexico City. Photograph by José Verde O.*

awareness of the relationship of art and society but also recognized the role of art as a tool in stimulating an aroused social conscience.

Orozco has described Dr. Atl at that time as having

> carried in his arms the rainbow of Impressionism and all the audacity of the School of Paris. . . .
>
> When not working, Dr. Atl, with his easy-flowing, enthusiastic and descriptive words would tell us of his travels in Europe and life in Rome; with passionate excitement he would speak of the Sistine Chapel and of Leonardo. Those huge Renaissance frescoes, somewhat incredible and as mysterious as the pyramids of the Pharaohs, the technique of which had been lost for four hundred years![3]

As one of Dr. Atl's students, the enthralled Diego Rivera absorbed everything the teacher said, and was fired by the desire to explore the new approaches to art being developed across the sea.

The tangible influence Dr. Atl exercised upon Rivera in this period can be seen in *View of the Snowcapped Mountain Citaltepetal*, painted in 1906 (Color Plate 1), in which natural beauty, light, and atmosphere are combined. The mood is further enhanced by subtle transitions of chromatic values, ranging from a foreground of strong, warm red browns, grays, and greens of trees to a subtly illuminated distant snow-capped mountain (Orizaba) rising in pale mists and silhouetted against a bright sky. The technique is marked by great freedom and directness of brushwork.

Self-Portrait (Color Plate 2 and Plate 31) of this period is endowed with the technical proficiency and broad appeal which were to become distinguishing features of Rivera's work.[4] Because of his capacity for selective emphasis as well as for objective statement, Rivera's portraits usually attain convincing, though rarely flattering, characterization. In this self-portrait the solidity of forms still suggests Velasco, but the technique brings to mind the brushwork of the impressionists. Except for a single, isolated touch of red, the colors are limited to black, green blue, ocher, and flesh tones. One unusual motif, not employed in earlier or subsequent works, is the conspicuous, enclosed red monogram at the upper left corner on the flat blue gray of the background. Both

Plate 31. Self-Portrait, *by Diego Rivera. Oil on canvas,* 1906 *(restored, see also Color Plate 2), 55 x 44 cm. Courtesy of National Institute of Fine Arts, Mexico City. Photograph by José Verde O.*

the organization of the composition and the use of the monogram indicate that Rivera was already aware of contemporary trends in French painting. In Paris an interest in Japanese prints as an art form had stimulated the use of asymmetrical composition, unusual points of view, bold silhouette, and forceful and satirical characterization—devices closely associated with the work of Henri Toulouse-Lautrec (1864–1901) and his followers. The monogram device, which Toulouse-Lautrec used, had also been derived from the forms of the artists' signatures on Japanese prints.[5]

Thus it was that by 1907, when Rivera set forth on his first journey to Europe, he was already a sensitive and skilled artist, sophisticated in his use of medium and perceptive in his interpretation of subject. He was fully prepared for the new perspectives that awaited him abroad.

NOTES FOR CHAPTER III

[1] Conversation with Rivera.

[2] Conversation with Rivera.

[3] Orozco, *Autobiography*, 19.

[4] The *Self-Portrait* was brought to the attention of the directors of Mexico's National Palace of Fine Arts in 1948–49, when the exhibition "Diego Rivera—Fifty Years of His Art" was in preparation. The painting has since been restored. Both the original and the restoration are shown in Color Plate 2 and Plate 31, respectively.

[5] The interest in Japanese prints, which began in the second half of the nineteenth century also affected Degas, van Gogh, and others, including Picasso, whose work was directly influenced for a brief period by that of Lautrec.

COLOR PLATES

Color Plate 1. View of the Snow-capped Mountain Cit-laltepetl, *by Diego Rivera. Oil on canvas, 1906, 0.36 x 0.235 m. Collection of Frida Kahlo Memorial Museum, Coyoacán. Photograph by Florence Arquin.*

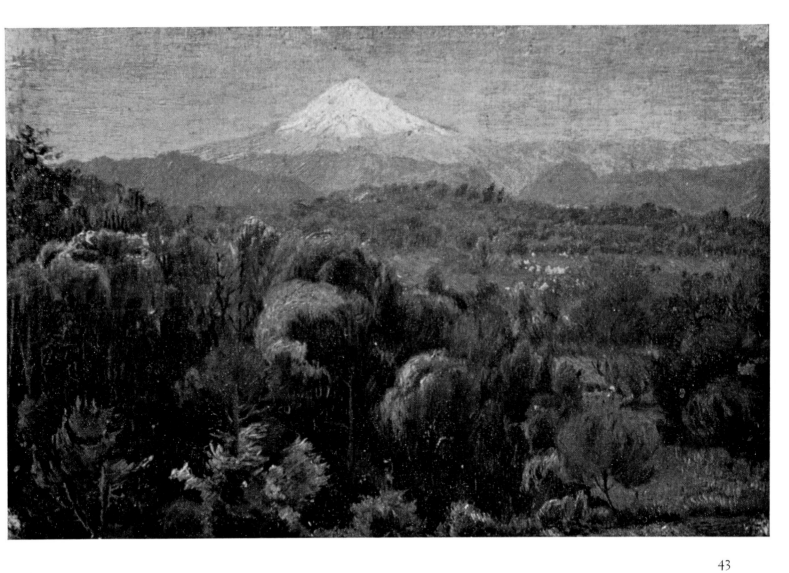

43

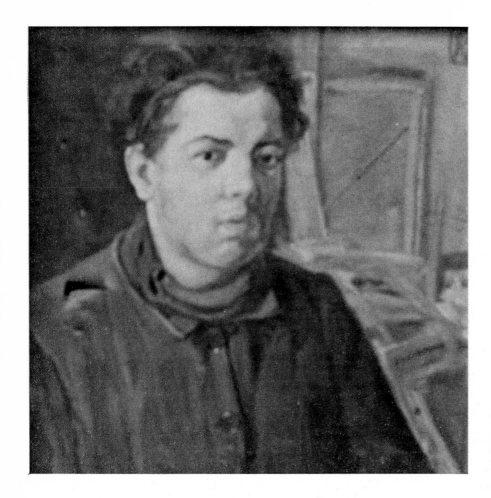

Color Plate 2. Self-Portrait, by Diego Rivera. (See also Plate 31.) Oil on canvas, 1906, 55 x 44 cm. Collection of Alfonso Cravioto, Mexico City. Photograph by Florence Arquin.

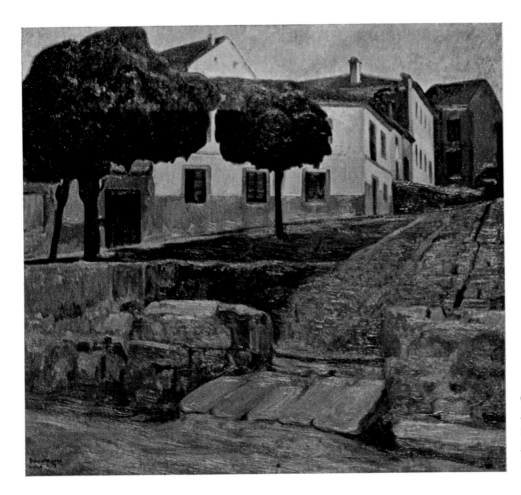

Color Plate 3. Streets of Avila, *by Diego Rivera. Oil on canvas, 1908, 1.27 x 1.40 m. Courtesy of National Museum of Modern Art, Mexico City. Photograph by Florence Arquin.*

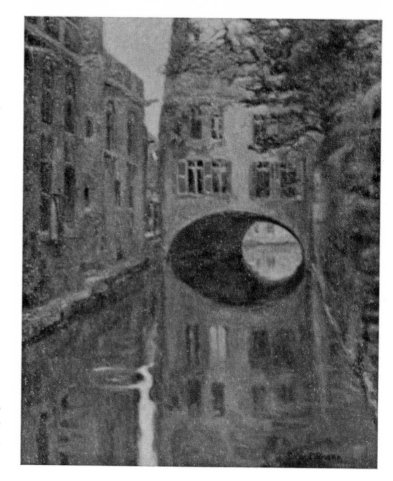

Color Plate 4. The House over the Bridge, *by Diego Rivera. Oil on canvas, 1909, 1.45 x 1.08 m. Courtesy of National Museum of Modern Art, Mexico City. Photograph by Florence Arquin.*

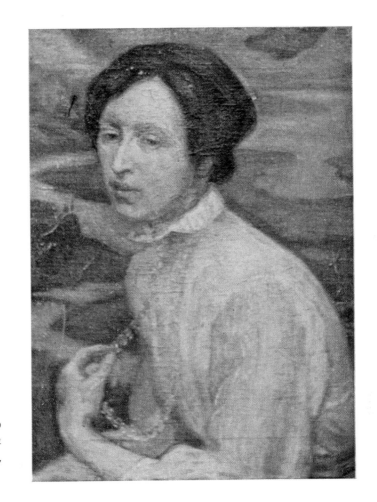

Color Plate 5. Portrait of Angeline Beloff, *by Diego Rivera. Oil on canvas, 1909–10(?). Collection of Ruth Rivera. Courtesy of National Institute of Fine Arts, Mexico City. Photograph by Florence Arquin.*

Color Plate 6. Portrait of Diego Rivera, *by Leopold Gottlieb. Oil on canvas, 1913. Collection of Marte R. Gómez. Courtesy of National Institute of Fine Arts, Mexico City. Photograph by Florence Arquin.*

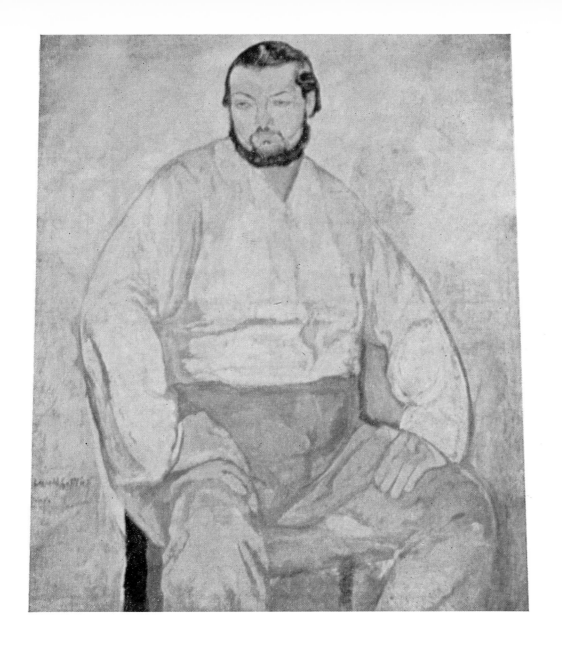

49

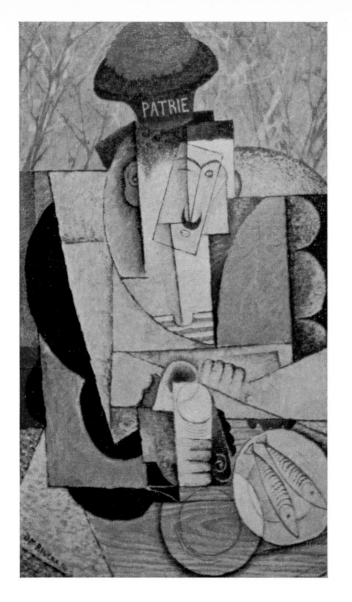

Color Plate 7. Marine Fusilier (*also known as* Sailor at Lunch), *by Diego Rivera. Oil on canvas, 1914, 1.14 x 1.70 m. Collection of Marte R. Gómez. Courtesy of National Institute of Fine Arts, Mexico City. Photograph by Florence Arquin.*

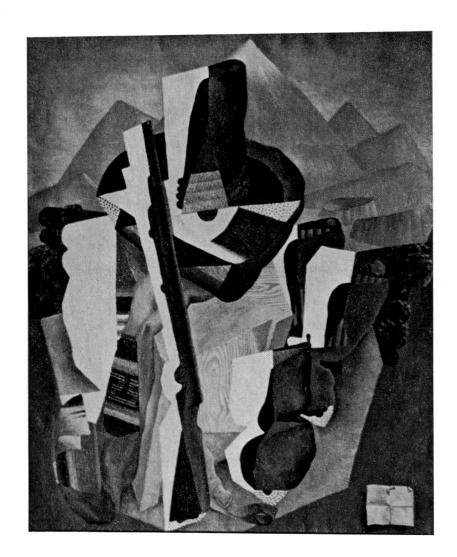

Color Plate 8. Zapata Landscape (*also known as* The Guerrilla Fighter), *by Diego Rivera. Oil on canvas, 1915, 1.44 x 1.23 m. Collection of Marte R. Gómez. Courtesy of National Institute of Fine Arts, Mexico City. Photograph by Florence Arquin.*

Color Plate 9. Portrait of Madame Marcoussis, *by Diego Rivera. Oil on canvas, 1915, 1.46 x 1.14 m. Courtesy of* The Art Institute of Chicago, Gift *of Georgia O'Keeffe. Photograph by Florence Arquin.*

Color Plate 10. *(far right)* Still Life, *by Diego Rivera. Oil on canvas, 1918. Collection of Mr. and Mrs. Antonio Luña Arroyo. Courtesy of National Institute of Fine Arts, Mexico City. Photograph by Florence Arquin.*

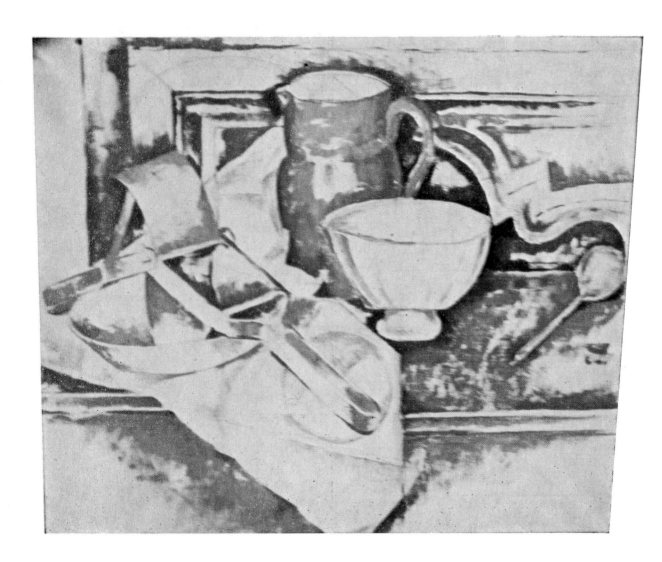

53

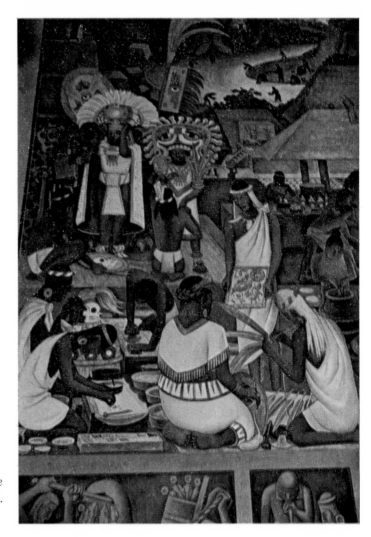

Color Plate 11. Detail of Tenochtitlán, panel in the National Palace, Mexico City, by Diego Rivera. Fresco, ca. 1945. Photograph by Florence Arquin.

54

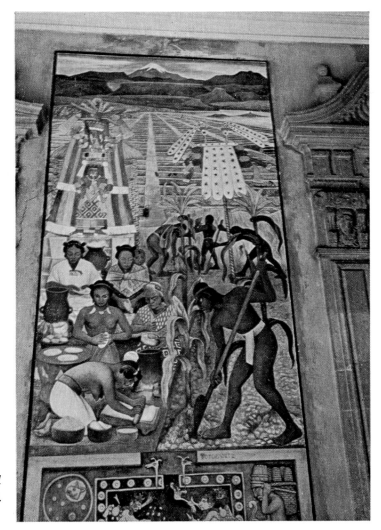

Color Plate 12. Tenochtitlán, *panel in the National Palace, Mexico City, by Diego Rivera. Fresco, ca.* 1945. *Photograph by Florence Arquin.*

STUDIES IN SPAIN, 1907-1908

The opportunity for Rivera to study abroad was provided by a grant from Teodoro Dehesa, then governor of the state of Veracruz, whose interest in the work of the young artist was aroused when Rivera visited and painted in the area. With Dehesa's promise of a subsidy of funds sufficient for three years' study in Europe, Rivera returned from Veracruz to Mexico City, where he supplemented those funds with the proceeds from a highly successful exhibition of his work, organized by Dr. Atl. Then, further fortified with Dr. Atl's letter of introduction to the Spanish painter Eduardo Chicharro y Agüera (1876–1949) in Madrid, Rivera left for Spain.

Soon after his arrival he began studying with Chicharro, who, although personally interested in color, nevertheless insisted upon Spanish realism in his teaching. Rivera was already familiar with the "official" school of black-shadow painting, which, though never truly popular, had flourished in Mexico between 1650 and 1730. In Spain the movement is represented by canvases attributed to Francisco de Zurbarán (1598–1664?) and Bartolomé Murillo (1617–82) in churches and public buildings. Fundamental to this style of painting were bold, dramatic composition; a limited palette of black and neutral colors; vigorous chiaroscuro; and vivid, intense characterization.

During Diego's sojourn in Spain, Madrid, unlike Barcelona, remained under academic domination. The environment had proved distasteful to the young Pablo Picasso and was equally uninteresting to Rivera. His discontent was partly mitigated, however, by his association with the artists Joaquín Sorolla y Bastida (1863–1923) and Ignacio Zuloaga (1870–1945), who shared his interest in impressionism.

Rivera's irritation, restlessness, and dissatisfaction with Spanish academicism and its rigid controls were inevitable, inasmuch as they followed immediately upon a period of self-directed growth and a sustained interest in impressionism—the very anti-

thesis of Spanish realism. The painting *Church of Lequeitio* of 1907 (Plate 32) attests to his current interests. The painting reveals the strong influence of impressionism, with its freedom of style and the opportunity it offered to paint outdoors, to concentrate upon the landscape instead of the somber still life and the formal portrait, to discard the restraints of academic technique in favor of spontaneous expression, and to experiment with brilliant color tones. The canvas not only illustrates the wide gap between Spanish academicism and French impressionism but also indicates the sharp contrasts that distinguish the technique of panoramic composition of earlier romantic realism, in which Rivera had trained under Velasco, and the selection of only a segment of a subject, the new approach to color, and the different technique in brushwork which characterize the work of the impressionists.

Despite such occasional "lapses" into impres-

Plate 32. Church of Lequeitio, by Diego Rivera. Oil on canvas, 1907, 1.09 x 1.895 m. Collection of Marte R. Gómez, Mexico City. Courtesy of National Institute of Fine Arts, Mexico City. Photograph by José Verde O.

sionism, Rivera nevertheless acquired a sound understanding of Spanish realism and its distinguishing characteristics. His command of the basic elements is demonstrated by the deft handling of medium and the dramatic compositions in representative canvases of the period. His subject, whether portrait or figure study, looms strikingly large in the foreground, and is usually made additionally powerful by a subordinated and simple background. The results, monumental and impressive, are typified in the figure composition *The Picador* of 1907 (Plate 33) and the portrait *Head of a Breton Woman* of 1908 (Plate 34). The portrait is of particular interest because in it Spanish realism is applied to a subject similar to those painted by Paul Gauguin in the late nineteenth century. The black-shadow phase of Rivera's training was similar to that undergone by Paul Cézanne between 1860 and 1870 and by Picasso before 1900— artists whose work was to be of particular significance in the development of his own.

Plate 33. The Picador, *by Diego Rivera. Oil on canvas, 1908, 1.72 x 1.075 m. Collection of Mrs. Lola Olmedo, Mexico City. Courtesy of National Institute of Fine Arts, Mexico City. Photograph by José Verde O.*

In addition, *Head of a Breton Woman* may be interpreted as a tendency toward postimpressionism, in that solidity of form is combined with great freedom and directness in technique, while quick, heavier brushstrokes indicate broad detail. The influence is again suggested in the landscape *Streets of Avila*, also of 1908 (Color Plate 3), in which the impressionist practice of concentrating upon a selected segment of a subject may be seen. The palette is limited to black, white, yellow ocher—almost gold— and a grayed blue for the sky. Rivera's unusual choice of color here is directly explained and supported by Gertrude Stein, who wrote in *Picasso* in describing Spain: "Spain is not like other southern countries, it is not colorful, all colors in Spain are white, black, silver, and gold.... Spain in this sense is not southern, it is oriental, women wear black ... the earth is dry and gold in color, the sky is blue, almost black."

Plate 34. Head of a Breton Woman, *by Diego Rivera. Oil on canvas, 1908(?), 0.585 x 0.585 m. Collection of National Institute of Fine Arts, Mexico City. Photograph by José Verde O.*

STUDIES IN FRANCE, 1909-1920

Bored with formal Spanish realism and eager to experiment and develop his own expression, Rivera soon abandoned his studies in Spain and went to France. Paris, where he established himself in 1909, as well as the stimulating challenge of fresh points of view and new styles and techniques in painting, finally satisfied the aesthetic, intellectual, and emotional needs of the young artist.

Rivera's first personal contact with the French painting of the period recalls his initial contact with Posada. One day, shortly after he arrived in Paris, Rivera set out to explore the city. As he was passing a commercial art gallery, he was attracted to a Cézanne painting in the window. He was later to learn that the gallery was that of the irascible Vollard, one of the first art dealers to sponsor avant-

garde painters of the period.[1] Rivera described the experience:

> I certainly did not look like a prospective customer; so Vollard at first must have decided I was a thief planning to break in and steal the painting. Otherwise, why would he have removed it from the window? Just as I was about to leave, he reappeared with a second and equally exciting canvas, which, without any indication of an awareness of my presence, he again placed before me. However, a few minutes later I could see my "friend" watching me from inside. Nevertheless, I remained, for this new picture was just as tantalizing and challenging as the previous one. Finally, and perhaps in exasperation, he returned, removed this work, and substituted still another. Soon it seemed like a game. Fascinated, I stood moored before this window for the remainder of that rainy day while Vollard, now probably as intrigued by my behavior as I was by his, proceeded to remove and replace canvas after canvas. This, the equivalent of a private showing, was my first and marvelous introduction to the original paintings of Cézanne, Matisse, van Gogh, Renoir, and others.
>
> This was the Paris I had come to find; this was where I would remain; and these were the artists and works I wanted and needed to know.[2]

And remain he did. For the next ten years Paris was his permanent headquarters, which he left only for a brief return to Mexico at the expiration of his first grant in 1910 and for intermittent short trips to other European countries.[3] Upon his return to Mexico in 1910, Rivera witnessed the opening events of the revolution against Díaz, which was soon to erupt in full force. He was so impressed by the uprising, which he dramatized and romanticized, that he employed it as a major theme in his Mexican murals after 1921.

It is generally conceded that French paintings produced in Paris during the first ten years of the twentieth century—a period distinguished by intellectual investigation and accelerated activity in art—gave rise to all the great art movements of subsequent years. In particular, the prolific years from 1905 to 1907 were of such singular importance that they are often regarded as determinative in the evo-

lution of contemporary painting. In 1906, Henri Matisse exhibited his *Joy of Life*. In the same year—the year of his death—Cézanne produced his extraordinary work *The Bathers* and the paintings of Mont-Sainte-Victoire.

It was Cézanne's astute analysis and understanding of the inherent problems of his art that restored structure and organization to eminence as major elements in composition—elements which were ignored by Claude Monet and his impressionist group. Cézanne stressed the selection and simplification of forms. By his controlled use of complementary colors—beginning with blue and orange, to which he later added red and green—and by his precise values in modeling, he achieved volume, solidity, and depth. Cézanne was responsible for the authoritative and influential doctrine: "Treat nature by the cylinder, the sphere, the cone so that each side of an object or plane is directed towards a central point."[4] This concept, as interpreted by Picasso, Georges Braque, and Juan Gris, was the basis for analytical cubism.

Also in 1906, Picasso began his famous transitional canvas *The Young Ladies of Avignon*, which was completed in 1907 and which is now generally considered the first great cubist painting. Picasso's "compact composition of angular planes and the flattening of pictorial space indicates an interest in the late work of Cézanne,"[5] as does his use of blue and orange supplemented by a suggestion of green. The distortion of some of the heads in this painting indicates a further influence from Africa's Ivory Coast, which Matisse had brought to the attention of his fellow artists.[6] The early African sculptures consisted of three-dimensional masks, heads, and figures. Later African *gravé* figures in a flat pattern on wood and brass influenced cubism—not in imitation but because the African sculptors had resolved certain problems in which European artists were now becoming interested. Gertrude Stein commented that "in the end" African Negro sculpture "was an intermediate step toward Cubism."[7]

Rivera was fortunate to arrive in Paris at this time of enthusiastic experimentation and independent creative expression. Of comparable significance in his future development, both professional and personal, was his early affiliation with a group of foreign artists whose paintings are generally identi-

fied with the School of Paris (Color Plate 4 and Plate 35). This movement flourished during the period of the fauvists and other new influences on French art, which the foreign artists absorbed into their work.[8] In the group were many Russians, including Angeline Beloff (or Belhoff), who was to become Rivera's common-law wife (Color Plate 5). Like Rivera, these artists had been attracted to Paris by the provocative intellectual and artistic climate of the city, whose reputation as a cultural center had been established by Russian artists working in Paris, by journals and other printed media, and by Russian collectors, among whom Ivan Morosov and Sergei Stchoukine are best known. Stchoukine is said to have "bought many paintings, beginning with a Puvis de Chavannes and following with those of Monet, Manet, Boudin, Sisley, Cézanne, Pissarro, Gauguin, half a hundred Matisses and more than half a hundred Picassos."[9] In Russia, which was still under czarist rule, an avant-garde movement, said to be the most dynamic and vigorous outside Paris, was flourishing, and "Moscow had become one of the great artistic centers of Europe."[10] As early as 1912 the Russian artist Kazimir Malevich was already

Plate 35. Vegetable Market, *by Diego Rivera. Oil on canvas,* 1909(?), 49½ x 43½ *in. Collection of Alberto Mizrachi, Mexico City.*

working as a cubist; such now-famous painters as Aleksandr Rodchenko, Vasili Kandinsky, and Eliezer Lissitsky were to develop other major aspects in the evolution of nonobjective and abstract art in Russia.

In the summer of 1911, Rivera returned to Mexico, obtained a renewal of his grant, and immediately returned to Paris. Re-established, and now living with Angeline Beloff, he embarked on a series of experiments in many aspects of modern painting now associated with such movements as impressionism, pointillism (neoimpressionism), postimpressionism, cubism, futurism, orphism, and fauvism, and with such artists as Monet, Georges Seurat, Cézanne, Picasso, Braque, Jules Delaunay, Henri Matisse, and Auguste Renoir.

Characteristically, Rivera could not observe changing methods and movements without investigating and experimenting with them, for his own intellectual curiosity, combined with his passion for painting, made each new development a personal challenge. Typical of his work of this period of experimentation are such diversified paintings as *Landscape of Catalonia* of 1911 (Plate 36), executed in pointillist technique and suggesting the influence

of Camille Pissarro; the figure composition *The Sculptor Ortero*, probably painted in 1911 (Plate 37), based on the work of Cézanne and painted in oil on cardboard; and *The Eiffel Tower* of 1912–14 (Plate 38), indebted to Delaunay and the school of orphism.

Stimulated by Angeline Beloff's absorption in cubism, Rivera was soon fascinated by this new direction in painting—the more so after he met Picasso, who subsequently became not only a close friend but also a major force in Rivera's development as an artist. For the time, however, Rivera's model remained Cézanne. Rivera's close study of Cézanne's paintings confirmed and intensified his admiration and respect for the French artist. Cézanne was Rivera's "great master" at the time—and indeed remained so throughout Rivera's life.

As early as 1912, in *Landscape with Farmhouse* (Plate 39), the authority of Cézanne is indicated by Rivera's choice of subject, composition, technique, and the unusual emphasis upon red and green. The same influence is evident in such paintings as *Landscape of Toledo* of 1912 (Plate 40), the portrait *Peasant in Blue Smock* of about 1913 (Plate 41), the

figure composition *Outskirts of Toledo* of 1913 (Plate 42), and *Landscape near Toledo*, also of 1913 (Plate 43). The Toledo landscape, although derived from Cézanne, is also representative of the School of Paris.

The year 1913 was one of intense activity for Rivera. He did, however, pause to be painted by Leopold Gottlieb (Color Plate 6), who presented him as a huge, calm individual in a mood of pensive concentration that was to become characteristic. Already marked was a slight squint of the left eye which developed whenever Rivera studied a model. The implication in this work is that even as he sat for his portrait he was mentally composing a painting of his fellow artist.

In retrospect, Rivera's prolonged adherence to the influence of Cézanne seems to confirm his own unusual artistic maturity. It has been said of Cézanne:

Although his work foreshadowed pure painting and abstraction, he strove to make faithful copies of reality and to translate light into paint. In wanting to achieve truth he surpassed the realistic impressionism of his day. In his own words, he was the primi-

Plate 36. Landscape of Catalonia, by Diego Rivera. Oil on canvas, 1911, 1.07 x 0.87 m. Collection of Dr. Luis Quintanilla. Courtesy of National Institute of Fine Arts, Mexico City. Photograph by José Verde O.

Plate 37. The Sculptor Ortero, *by Diego Rivera. Oil on drawing board, 1911, 45 x 38 cm. Collection of Marte R. Gómez, Mexico City. Courtesy of National Institute of Fine Arts, Mexico City. Photograph by José Verde O.*

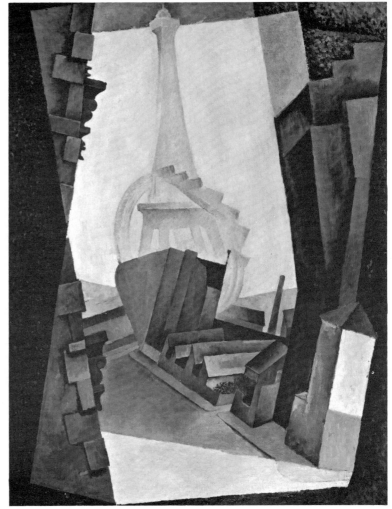

Plate 38. The Eiffel Tower, *by Diego Rivera. Oil on canvas, 1912–14, 1.15 x 0.89 m. Collection of Phillip Bruno, New York City.*

Plate 39. Landscape with Farmhouse, *by Diego Rivera. Oil on canvas, 1912(?). Collection of Mrs. Lola Olmedo, Mexico City. Photograph by Taylor and Dull, New York City.*

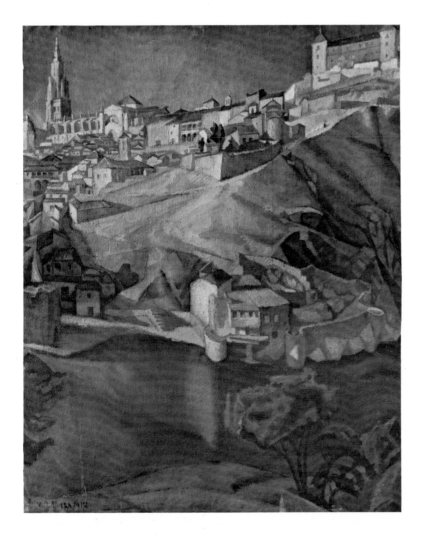

tive of a new art. . . . With him a whole epoch of art was closed and a new one opened.[11]

Despite his continued esteem for Cézanne, Rivera, now curious about and excited by cubism, joined its adherents. Among them was Juan Gris, whose systematic and clear organization of composition and use of texture and pattern were to be of marked and lasting influence on Rivera.

At that time analytical cubism, which was based upon an austere, objective, and essentially intellectual reduction of forms into their basic geometric volumes and planes, was already evolving into its synthetic phase. The earlier analytical period had retained the illusion of something of a third dimension and had contributed a new mental image by simultaneously presenting multiple views of the subject as visualized from a series of points of view. Synthetic cubism represented selections of the numerous

Plate 40. Landscape of Toledo, by Diego Rivera. Oil on canvas, 1912, 1.12 x 0.91 m. Collection of Mrs. Carmen Vasconcelos de Ahumada, Mexico City. Courtesy of National Institute of Fine Arts, Mexico City. Photograph by Florence Arquin.

Plate 41. Peasant in Blue Smock, *by Diego Rivera. Oil on canvas, ca. 1913, 31½ x 29 in. Collection of Mrs. Lola Olmedo, Mexico City. Photograph by Taylor and Dull, New York City.*

planes developed in analytical cubism, which were then reorganized on a two-dimensional plane. It emphasized more independent expression and permitted greater freedom by encouraging greater inventiveness. Bold, brilliant color displaced the earlier and prerequisite palette of black, white, grays, and ochers (earth colors). A new preoccupation with richness and variety in textures introduced such extraneous materials as colored and textured papers, newspapers, magazine clippings, playing cards, printed labels, and ticket stubs, which were pasted directly on the canvas and became integral elements of the total composition.

The movement toward synthetic cubism notwithstanding, Rivera was completely in character

Plate 42. (left) Outskirts of Toledo, *by Diego Rivera. Oil on canvas, 1913. Collection of Mrs. Lola Olmedo, Mexico City. Photograph by Taylor and Dull, New York City.*

Plate 43. (facing page) Landscape near Toledo, *by Diego Rivera. Oil on canvas, 1913, 35 x 43½ in. Collection of Mrs. Lola Olmedo, Mexico City. Photograph by Taylor and Dull, New York City.*

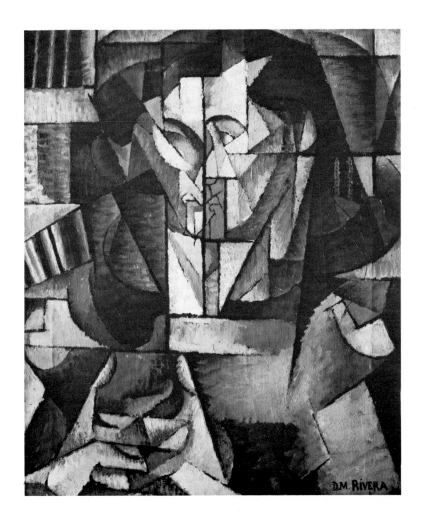

when he reverted to analytical cubism to produce a portrait of the sculptor Jacques Lipschitz, which has since become generally known as *Young Man in Gray Sweater* (Plate 44). In this work the precise technique and the dramatic interpretation of the subject as a figure of monumental dignity suggest the influence of Albert Gleizes, a fellow cubist. The painting exemplifies Rivera's need to experience and understand fully every new aspect of art with which he came into contact. He was later to say proudly of this work: "Though I still had not mastered the Cubist idiom, the latter painting, in particular, was well received. Even today it is admired. . . . It is a well-constructed canvas done with warmth and grace."[12]

Now satisfied that he understood the limitations of analytical cubism, Rivera was free to concentrate on the techniques of the synthetic phase of the movement. In 1914 he painted a succession of canvases that marked an evolution in technique from the use

Plate 44. Young Man in Gray Sweater (*also known as* Portrait of Jacques Lipschitz), *by Diego Rivera. Oil on canvas, 1914, 0.65 x 0.55 m. Courtesy of The Museum of Modern Art, New York City.*

of thin paint and smooth surfaces to one employing heavy impasto and resulting rough textures. In the same year Rivera renewed what was to become a growing concern with Mexican subject matter.

Representative of this period and particularly of the evolution in technique are *Young Man with Stylograph* (Plate 45); *Marine Fusilier*, also known as *Sailor at Lunch* (Color Plate 7); *The Rooftops* (Plate 46); and *Shore of Mallorca* (Plate 47). All these paintings emphasize texture achieved by means of different painting techniques as well as by the use of pattern.

Young Man with Stylograph is distinguished by its elegant simplicity, clarity in organization, and direct statement. Although within the realm of synthetic cubism, the work differs from others of that school in that the subject is portrayed as seen simultaneously from a number of points of view—a feature that characterized the earlier, analytical form.

In contrast, *Marine Fusilier* is a bold, engaging,

Plate 45. Young Man with Stylograph, *by Diego Rivera. Oil on canvas, 1914, 32 x 25½ in. Collection of Mrs. Lola Olmedo, Mexico City. Photograph by Taylor and Dull, New York City.*

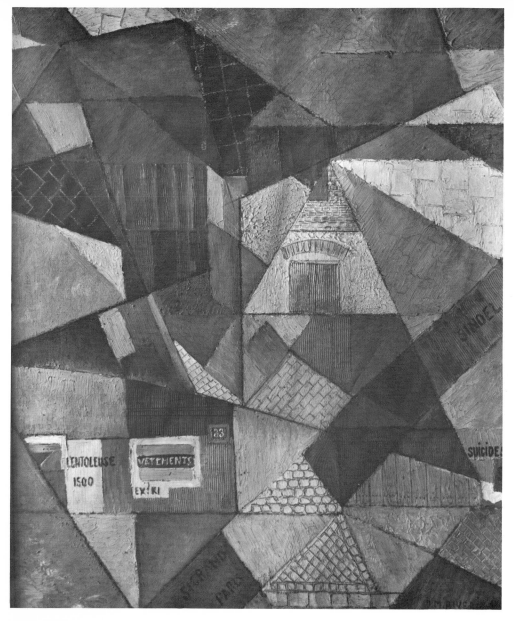

Plate 46. The Rooftops, *by Diego Rivera. Oil on canvas, 1914, 0.635 x 0.54 m. Collection of Martín Luis Guzmán. Courtesy of National Institute of Fine Arts, Mexico City. Photograph by José Verde O.*

Plate 47. Shore of Mallorca, *by Diego Rivera. Oil on Canvas, 1914, 0.652 x 0.85 m. Collection of Dr. Alfonso Reyes, Mexico City. Courtesy of National Institute of Fine Arts, Mexico City. Photograph by José Verde O.*

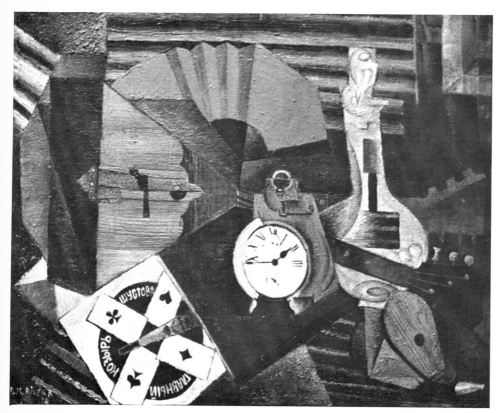

Plate 48. The Awakener (*also known as* The Clock), *by Diego Rivera. Oil on canvas, 1914, 0.63 x 1.45 m. Collection of Frida Kahlo Memorial Museum, Coyoacán.*

decorative work—and one more truly representative of synthetic cubism. Unlike Rivera's earlier canvases, this painting has a heavier application of pigment, richer color, and greater variety in textures, shapes, and motifs and includes such unusual elements as wood grain and lettering. Brief reference to analytical cubism may again be inferred by the simultaneous representation of both front and top views of a glass held by the model. The color includes the striking use of black, white, numerous grays, rich blue, and a brilliant red that tops the sailor's hat. A fascinating and deliberately inconsistent feature is the naturalistic rendering of the upper third of the canvas. Here the light grayed green of the sky is laced with realistic, dull-red branches of bare trees. The jolting contrast between the lightness and open pattern of this area and the strong, compact organization of the main theme, which all but fills the canvas and is in part silhouetted against the upper section, tends to intensify the flat pattern, power, and formal organization of the subject and to convey an impression of both foreground and background through association of ideas as well as through the two differing styles of painting.

Witness to Rivera's progressively intensified interest in textures is *The Rooftops*. This painting of rooftops and walls as seen from above might well be subtitled "Variations in Textures and Pattern in the Manner of Juan Gris." The composition is based on a juxtaposition of variegated shapes, sizes, and colors augmented by diversified pattern, textures, numerals, and lettering. Although a casual viewer can gain a first, superficial impression of abstraction in the painting, like most of Rivera's other works, it is intrinsically realistic and conveys a genuine impression of certain old sections of Paris. The charm of the canvas rests not only upon color and texture but also—and even more significantly—upon sensitive relationships, established by means of composition and technique.

Shore of Mallorca, another 1914 painting, illustrated Rivera's interest in texture. Here, despite his personal preference for thin paint and smooth surfaces, he uses a heavy impasto and a fool-the-eye technique to create distinctive textures and tactile qualities. In this work foreground rocks and a rolling sea are emphasized. To achieve desired results, artists of the synthetic group, including Rivera, used sand and other texture-producing elements which, when mixed with oil paint, provided a variety of irregular and coarse-grained surfaces. That method is strongly suggested in the work and once again demonstrates Rivera's insatiable need to test each innovation in technique—even one that had no special appeal to him.

Of great significance, in subject matter rather than innovation in technique, is *The Awakener* (also known as *The Clock*) (Plate 48), a work that again strongly reflects the influence of Juan Gris. The painting differs from Rivera's earlier European works in that he has begun to introduce motifs of more personal and associative interest—here a multicolored Mexican serape and such Russian elements as a balalaika and a label conspicuously printed in Cyrillic letters. Whether or not by coincidence, Picasso produced his *Still Life with Russian Lettering* in the same year.[13]

Rivera's technical virtuosity is demonstrated in *The Bullfight Ring* of 1915 (Plate 49), which has particularly rich and varied surface textures, achieved by a manipulation of heavy pigment. More significantly, however, the painting indicates Rivera's need

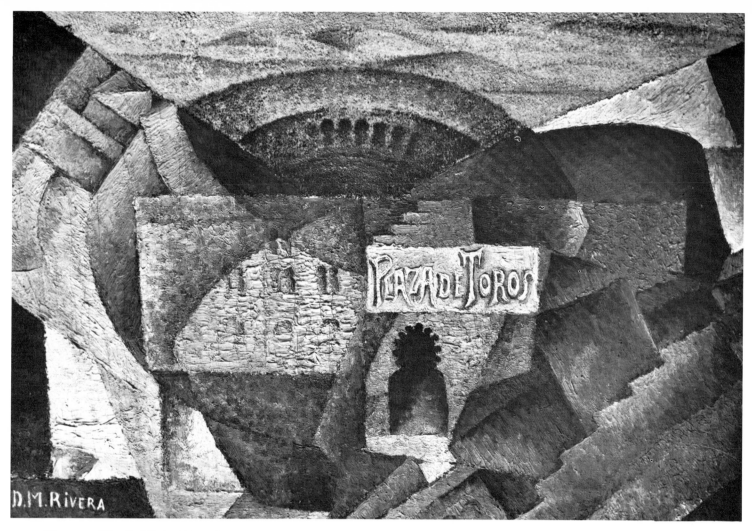

Plate 49. The Bullfight Ring, *by Diego Rivera. Oil on canvas, 1915, 0.475 x 0.70 m. Collection of Dr. Alfonso Reyes, Mexico City. Courtesy of National Institute of Fine Arts, Mexico City. Photograph by José Verde O.*

to identify himself with his own cultural traditions, as implied by his selection of subject matter and by the inclusion of Spanish lettering. Although painted during a stay in Madrid, this frankly Spanish-Mexican theme, despite its cubistic rendering, is readily identified and is endowed with the descriptive and realistic qualities that characterize all of Rivera's work, irrespective of style. Disregarding any technical or aesthetic evaluation, we can now see this painting as an early foreshadowing of Rivera's devoted identification with his own country. Indeed, the specific element of association may have prompted the selection of subject matter.

Further evidence of Rivera's emotional need to identify himself with his own heritage is the forceful *Portrait of Martín Luis Guzmán* of 1915 (Plate 50), which again demonstrated Rivera's ability to portray convincingly the innate character of his subject. In this painting the seated figure wears a bullfighter's

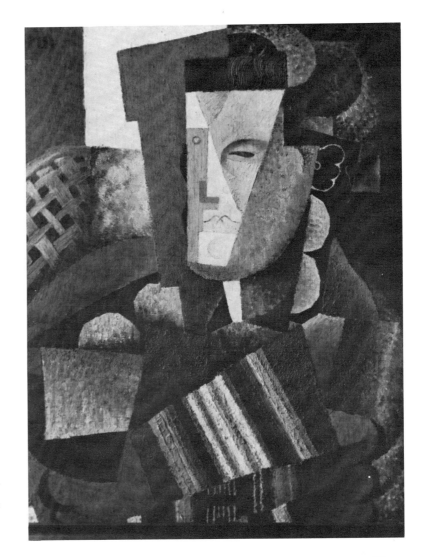

Plate 50. Portrait of Martín Luis Guzmán, *by Diego Rivera. Oil on canvas, 1915, 71 x 58 cm. Collection of Martín Luis Guzmán, Mexico City. Courtesy of National Institute of Fine Arts, Mexico City. Photograph by José Verde O.*

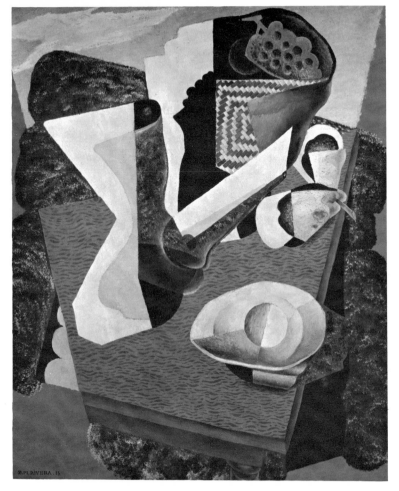

Plate 51. Still Life with Gray Bowl, *by Diego Rivera. Oil on canvas, 1915, 32.0 x 25.5 cm. Photograph by Taylor and Dull, New York City.*

hat, which suggests the complete bullfighter's costume. A folded Mexican serape, at the lower right of the canvas, suggests a cape over the arm of a bullfighter. Like all paintings of the synthetic-cubist movement, this work places emphasis upon texture and tactile qualities.

The trend toward utilizing native Mexican motifs was continued by Rivera in the *Still Life with Gray Bowl*, also of 1915 (Plate 51). A straw mat, unmistakably Mexican, provides a pattern that supplements the various other textures created by painting techniques. This canvas is also in the manner of synthetic cubism and demonstrates the continuing influence of Juan Gris.

Mere Mexican motifs soon gave way to a completely Mexican theme, as in *Zapata Landscape* of 1915 (Color Plate 8). Sometimes called *The Guerrilla Fighter*, this painting is a cubist representation of the uniform and fittings of a revolutionary irregular. Emphasis is placed upon a large and conspicuous rifle, a Mexican sombrero, and an equally Mexican serape, painted so accurately and in such detail that Saltillo, a city noted for this particular type of blanket, is brought to mind. Placed in a landscape

peculiar to the highlands of Mexico, these motifs symbolize the social and political aspects of the theme. The painting is an early indication of the social significance that was to mark Rivera's work after his return to Mexico. The calm strength and structural quality of the canvas, as well as the simplification of the background landscape to suggest geometric forms, suggest a retained influence of Cézanne. This is also true of the palette, which is dominated by strong tones of rich blue and red orange, with a discreet touch of red and green. The painting is further enhanced by a dramatic and forceful use of black and white. The subject, which all but fills the canvas, is silhouetted against the intense blue of the foreground, and rises from this base to reach the uppermost tip of snow-capped mountains, which, in turn, are seen against the cool grayed blue of a light sky. The horizon, cut by the figure of the guerrilla, drops at one side, in the manner of Cézanne, to create a sense of movement in space. *Zapata Landscape*, like other works of the period, confirms Rivera's maturity and dexterity as an artist. It also demonstrates his interest in textures and a fool-the-eye technique, as evidenced by the textural quality of the serape, by the wood grain of the rifle butt, and—even more conspicuously—by the treatment of a large block of wood that is centrally prominent in the composition. Fool-the-eye technique is again emphasized by the folded paper nailed to the lower right corner of the canvas, a device occasionally employed by El Greco. In a later evaluation of this work Rivera was to say that, although it had been "executed without any preliminary sketch in my Paris workshop, it is probably the most faithful expression of the Mexican mood that I have ever achieved."[14]

Despite the early date and foreign locale of *Zapata Landscape*, Rivera's use of a large scale, a bold silhouette, and brilliant color anticipates the basic qualities that were to be identified with Mexican painting of the postrevolutionary period—so much so that *Zapata Landscape* may be considered a forerunner of the Mexican renaissance. This canvas, in both emphasis and interpretation, suggests a further development of ideas that apparently first gained expression in *Marine Fusilier*.

In all likelihood, Rivera's 1915 visit to Madrid temporarily dispelled his nostalgia for his native land. After returning to Paris, he seldom used Mexican

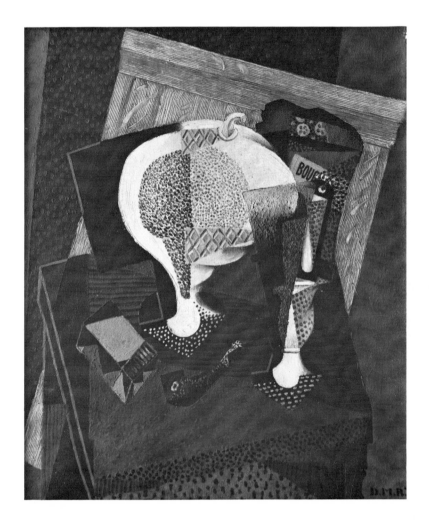

elements in his work. The still life *The Sugar Bowl and the Candles* (Plate 52) typifies the truly French character of his painting in this period. It also demonstrates the strong influence of synthetic cubism. Rivera was now influenced by the technique of Picasso, whose work at that time incorporated a disciplined use of dots of color (pointillism), in the manner of Seurat. Rivera used the same method to enhance selected areas in his own compositions. A fool-the-eye technique, utilized in the representation of wood grains in *The Sugar Bowl and the Candles*, lends additional interest because it shows the influence of Braque.[15] Also borrowed from Braque was Rivera's use of a stencil, in the form of a monogram, for his signature. Of further and special interest in relation to Rivera's later painting is the social significance implied by the inclusion of a common clay pipe as a pictorial element. This motif is said to have been the symbol, if not the signature, of the poor artist in Paris at the time.

Plate 52. The Sugar Bowl and the Candles, *by Diego Rivera. Oil on canvas, 1915, 0.645 x 0.54 m. Collection of Alfred Stieglitz, New York City. Photograph (by José Verde O.) courtesy of National Institute of Fine Arts, Mexico City.*

Among Rivera's many friends and associates of this period were Amedeo Modigliani, Pieter Mondrian, Delaunay, the Japanese Foujita, the sculptor Jacques Lipschitz, the writer Max Jacob, the poet André Salmon, and the poet-critic Guillaume Apollinaire. Rivera also had a number of Russian friends, including the sculptor Aleksandr Archipenko and the writer Ilya Ehrenburg. It may be inferred that the status of art and the accomplishments of artists in Russia were providing the major stimulus to Rivera's work. Then, too, there was the influence of his Russian wife. Certainly his later philosophy about the role of art in the structure of modern society stemmed in large measure from those early associations. Rivera's continuing concern with matters relating to Russia may be attributed, at least in part, to happy memories of his years in Paris.

A portrait of Rivera painted by Modigliani in 1916 (Plate 53) is a perceptive likeness of Rivera at that particularly significant time. The portrait can

Plate 53. Portrait of Diego Rivera, *by Amedeo Modigliani. Gouache and oil on cardboard, 1916, 1.00 x 0.81 m. Courtesy of Museum of Art of São Paulo, Brazil.*

be compared with Leopold Gottlieb's portrait of 1913 (Color Plate 6) and with a photograph of Rivera (Plate 54), taken in 1909 when he was a student in Madrid. In the Modigliani portrait the artist used both gouache and oil paint on a background of cardboard.

Representative of Rivera's technique at this time, as well as of his understanding of the salient qualities of his models, are *Portrait of Madame Marcoussis* of 1915 (Color Plate 9) and *The Architect*, probably of 1916 (Plate 55). Each is distinctive for vivid and trenchant portrayal of the subject, a characteristic quality of Rivera's work from his student days.

Madame Marcoussis holds additional interest in that the palette of analytical cubism, supplemented by a band of intense, cold yellow at the left side of an object—probably a book held upright in the model's lap—is used in an interpretation in the manner of Juan Gris and synthetic cubism. The subtly balanced

Plate 54. Diego Rivera, 1909. Collection of Bertram D. Wolfe. Photograph courtesy of National Institute of Fine Arts, Mexico City.

organization of color in this asymmetrical composition affirms the relationship of the two dominant motifs, the book and the model's face, and simultaneously establishes balance. Rivera also employs a fool-the-eye technique to add variety, interest, and contrast and to augment the richness of the model's gown with a pattern extending in a strong, wide diagonal plane from the hands and lower edge of the book in the lap to the right shoulder and across the base of the neck. The forceful thrust and direction of this area show the relationship between the book and the model's head and at the same time intensify the emphasis already established through the use of color.

The Architect captures the intrinsic poise and dignity of the model. The methodical organization of this work reiterates the influence of Juan Gris, whereas the inclusion of wood grain and stenciled monogram is attributable to Braque.

Obviously Rivera was fascinated by the chal-

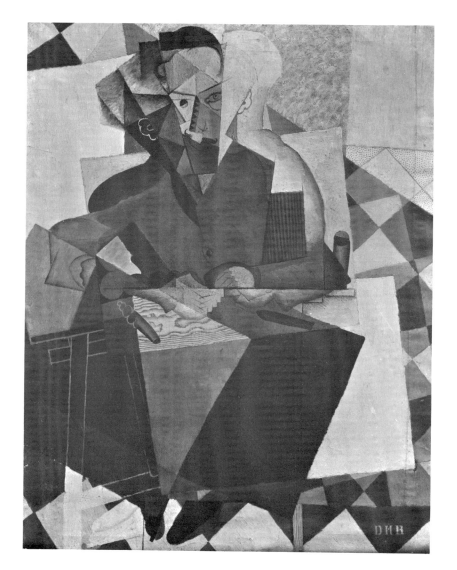

Plate 55. The Architect, by Diego Rivera. Oil on canvas, 1915, 1.43 x 1.13 m. Collection of National Museum of Fine Arts, Mexico City. Photograph by José Verde O.

lenge of a seated figure interpreted within the limitations of synthetic cubism. In 1916 he painted two more seated figures, *Portrait of Maximilien Volochine* (or *Voloshin*) and *Woman in Green*. They were followed in 1917 by *Woman in an Armchair* (Plate 56), which in composition, resolution of technical problems, and general effect is reminiscent of *Madame Marcoussis*.

After painting as a cubist for three years, Rivera shocked his fellow artists in Paris by declaring that modern revolutionary art, while taking advantage of all technical gains, should nevertheless be simple enough to be understood by the common people. He was convinced that only the growth of a new standard of taste on the part of the working classes would assure a true cultural revolution.[16] He proposed linking art with the community and the larger issues of life by replacing art for art's sake with a new art of content. Thus he categorically re-established the respectability of subject matter and brought about a break in the approved tradition of French painting, in which synthetic cubism was the current style. Many years later, in 1943, Rivera was to say of himself in this period:

I stopped painting in the cubist manner because of the war, the Russian Revolution, and my belief in the need for a popular and socialized art. It had to be a functional art, related to the world and to the times, and had to serve to help the masses to a better social organization. In cubism there are many elements that do not meet this specific need. Nevertheless, the plastic values of cubism can be utilized without these limitations. In fact, I have never left cubism. My paintings now are more truly cubist than when they looked like cubism.[17]

It must be remembered that, from the time Rivera returned to Europe in 1911, he was well prepared to assimilate and utilize the great wealth of pictorial experience that was to be his, for he possessed both the cultural and the technical background to do so. As a result, some of the canvases of this period, though indebted to many influences, were nevertheless stated with independence and strong personal style—so much so that the French critics of the day, reviewing current exhibitions in which Rivera and his colleagues participated, spoke

of him as they did of their own great artistic leaders. It was said that Rivera

> contributed considerably to the cubist movement encouraged by the poet-critic Guillaume Apollinaire, taking a most important place among his confreres, and even originating by his singular views a "doctrinaire complex" called "l'Affaire Rivera," . . . discussed at length by such an authoritative critic as André Salmon, who exclaimed: "There is no heavier volume in space than that of Diego M. Rivera. There is nothing that is more suspended." The same critic also praised "the combination of strength and delicacy in his work."[18]

Diego Rivera himself later said:

> I have always been a realist, even when I was working with the cubists. That is why in Paris they used to call me the Courbet of cubism. I believe this movement to be

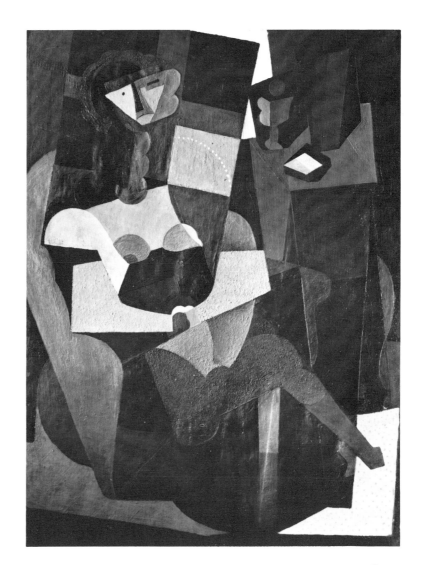

Plate 56. Woman in an Armchair, by Diego Rivera. Oil on canvas, 1917. 1.30 x 0.97 m. Collection of Dr. Alvar Carrillo Gil, Mexico City. Photograph (by José Verde O.) courtesy of National Institute of Fine Arts, Mexico City.

the most important single achievement in plastic art since the Renaissance. I also believe that my cubist paintings are my most Mexican. Inside them there are plastic qualities—certain specific ways of expressing proportion and space, certain special and personal theories and practices in the use of color—that are my own invention and belong to me.[19]

In his dissatisfaction with the limitations of cubism and his revolt against it (1917–20), Rivera deliberately reverted to the early classicism of Ingres, to the powerful contribution of his first European "great master," Cézanne, and to impressionism as interpreted by Renoir.

The pencil drawing *Woman on a Sofa* of 1917 (Plate 57) reminds us of the composition of Ingres and of the elegance and refinement of his draftsmanship, while demonstrating Rivera's own finesse in handling the medium. Although his skill in drawing was a natural endowment—marked even in early boyhood—his powerful and expressive use of the talent must be attributed, at least in part, to the rigid discipline of his early training at the San Carlos Academy in Mexico.

Another pencil drawing of the same year, *Portrait of Chirokoff* (Plate 58), is reminiscent of drawings by Picasso in which the influence of Ingres is indicated. An unusual note in this study is the introduction of a surrealist touch—a self-portrait of Rivera at work reflected in the corner of a monocle worn by the model. These pencil drawings may be accepted as part of a series that continued into the following year, when Rivera produced his provocative *Self-Portrait* (Plate 59) and the delicate yet vivid *Portrait of Madame Fisher* (Plate 60).

The classical influence is also seen in the painting *Portrait of Levedeff* of 1918 (Plate 61). The technique demonstrates Rivera's preference for smooth surfaces, thin paint, and controlled, light brushstrokes.

Although Rivera had disavowed cubism, a retained influence from his participation in the movement, supplemented by the authority of Cézanne, is intrinsic in such works as the pencil drawing *Still Life with Lemons* of 1918 (Plate 62) and is even more

(*Text continues on page 92*)

Plate 57. Woman on a Sofa, by Diego Rivera. Oil on canvas, 1917, 0.46 x 0.30 m. Collection of Marte R. Gómez, Mexico City. Courtesy of National Institute of Fine Arts, Mexico City. Photograph by José Verde O.

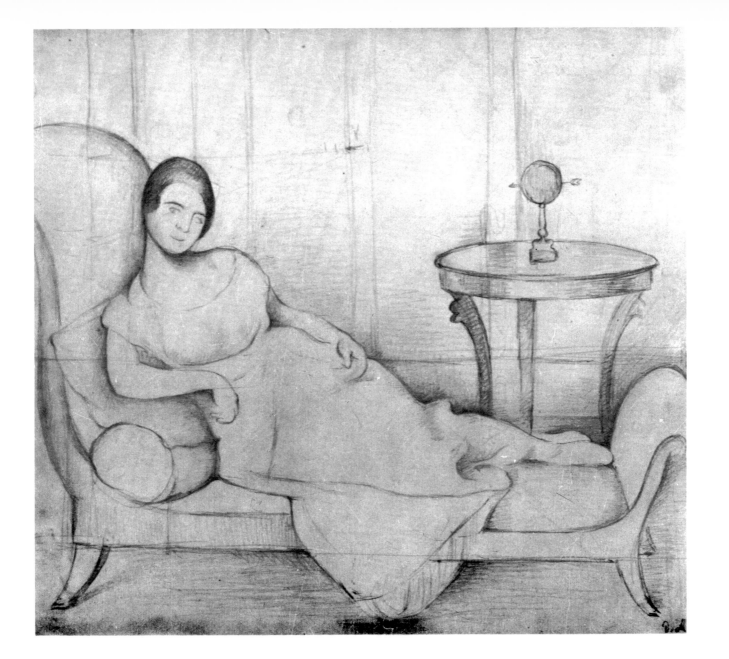

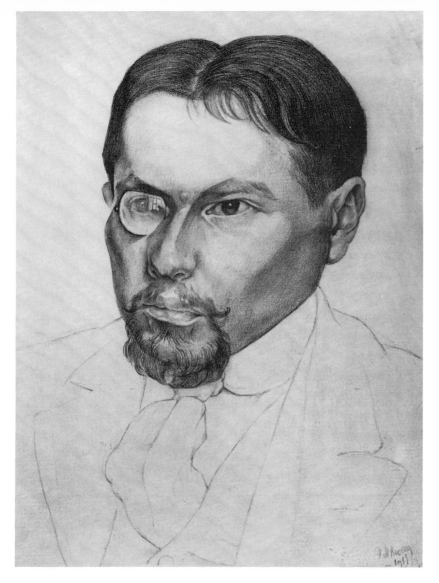

Plate 58. Portrait of Chirokof, *by Diego Rivera. Pencil drawing on paper, 1917. Owned by Worcester Art Museum, Worcester, Massachusetts.*

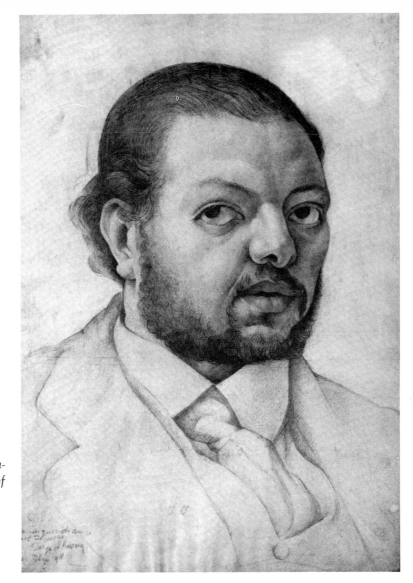

Plate 59. Self-Portrait, by Diego Rivera. Pencil drawing, 1918, 35 x 24 cm. Collection of Carl Zigrosser, Philadelphia.

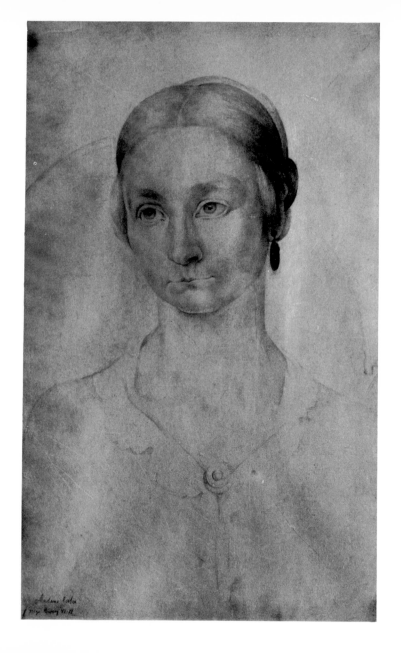

emphatic in the unfinished *Still Life,* also of 1918 (Color Plate 10). The power of Cézanne's influence is similarly evident in such paintings of the same year as *Aqueduct* (Plate 63) and *The Mathematician* (Plate 64).

Among the many and varied influences to which Rivera was exposed during his years in Europe, the most lasting and consequential were those derived from Cézanne and cubism—influences that held in common a highly objective and intellectual approach to all problems in painting. Rivera was also strongly drawn to the work of Seurat, who shared the same approach.[20] It was to characterize Rivera's solution of the aesthetic and technical problems of his later work in Mexico.

(*Text continues on page 96.*)

Plate 60. Portrait of Madame Fisher, *by Diego Rivera. Pencil drawing, 1918, 46 x 30 cm. Courtesy of Fogg Art Museum, Harvard University, Bequest of Meta and Paul J. Sachs.*

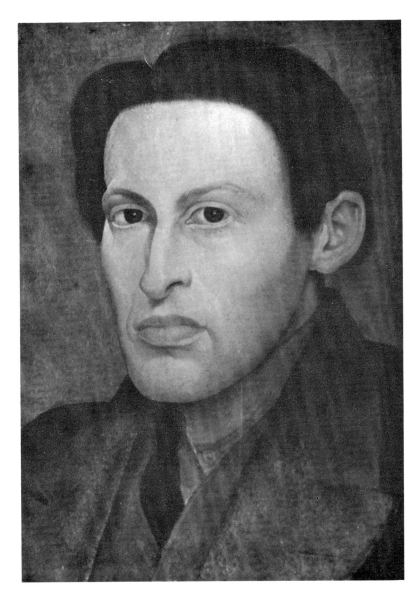

Plate 61. Portrait of Levedeff, *by Diego Rivera. Oil on canvas, 1918, 39 x 245 cm. Collection of Salmon Hale, Mexico City. Photograph (by José Verde O.) courtesy of National Institute of Fine Arts, Mexico City.*

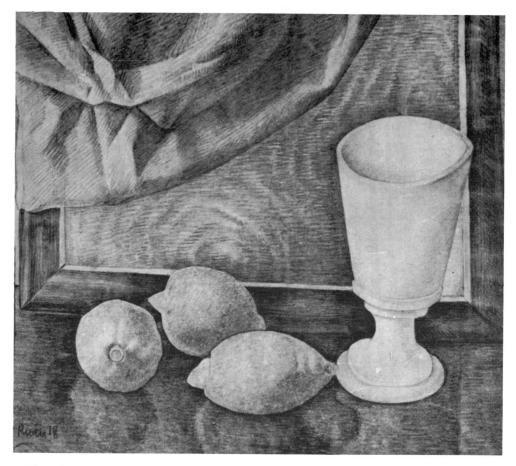

Plate 62. Still Life with Lemons, by Diego Rivera. Pencil drawing, 1918. Collection of J. M. de la Garza, Mexico City. Photograph (by José Verde O.) courtesy of National Institute of Fine Arts, Mexico City.

94

Plate 63. Aqueduct, by Diego Rivera. Oil on canvas, 1918, 65 x 54 cm. Collection of Mr. and Mrs. Charles Storke, Mexico City. Photograph (by José Verde O.) courtesy of National Institute of Fine Arts, Mexico City.

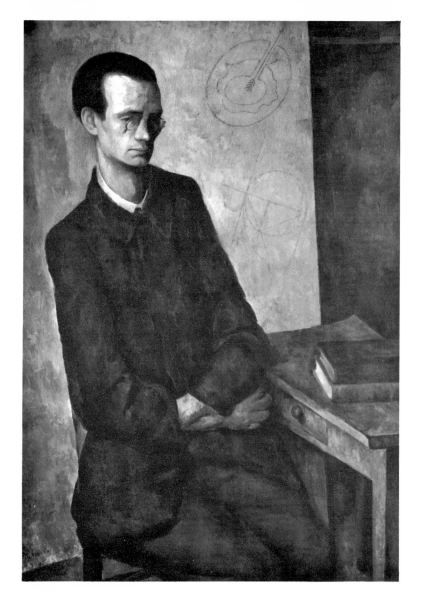

Rivera soon recognized the challenge in this disciplined approach to art and deliberately submitted himself to its requirements. He was not completely satisfied, however, for his intensely sensitive and passionate nature required subject matter expressive of that aspect of his character. It may have been Rivera's need for human qualities that gave impetus to his choice of subject in the canvas *Apple Vendor* (Plate 65). This work, painted in 1919 and marked by an overtone of social significance, is expressive of a point of view that was to be identified with much of Rivera's subsequent painting in Mexico.

As a next step in the logical progression of interests, Rivera turned to the exuberant painting of the fauvists. Identified particularly with the work of Matisse, André Derain, and Georges Rouault, fauvism derived from the work of Gauguin. Essentially emotional, and occasionally inspired by exotic

Plate 64. The Mathematician, *by Diego Rivera. Oil on canvas, 1918(?), 1.16 x 0.82 m. Collection of Ramón Beteta, Mexico City. Photograph (by José Verde O.) courtesy of National Institute of Fine Arts, Mexico City.*

sources, fauvist paintings are distinguished by brilliant, lyrical color organized in flat areas to create decorative effects. Rivera's *Landscape* of 1919 (Plate 66) is suggestive of a late phase of fauvism.

Much earlier, certain similar qualities had attracted Rivera to the work of Henri Rousseau (1844–1910)—frequently called the "modern primitive." His imaginative, fastidious, and deceptively subtle paintings never ceased to delight Rivera, who later frequently said that Rousseau was one of the most important artists of his time.[21]

Although freedom in technique and use of rich, dramatic color were in themselves exhilarating stimuli, they fell short of Rivera's immediate and specific goal–to restore to his painting such additional qualities as subject matter, volume, solidity of form, movement, and organization in deep space. He was attracted to Renoir, whose work—in the tradition of Peter Paul Rubens—was characterized not only by rich color and textures but also the other technical attributes Rivera was seeking.

Plate 65. Apple Vendor, by Diego Rivera. Oil on canvas, 1919. Courtesy of Gallery of Mexican Art, Mexico City.

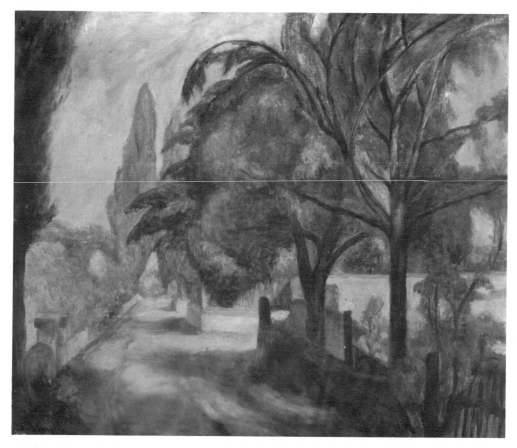

Plate 66. Landscape, *by Diego Rivera. Oil on canvas, 1919. Courtesy of Gallery of Mexican Art, Mexico City. Photograph by José Verde O.*

Rivera was also emotionally responsive to Renoir's work because of the vitality and penchant for living expressed in the French artist's paintings and because of their innately bourgeois and sensual qualities—qualities not unlike those in Rivera's own work. Rivera's new choice of subject, the female nude (Plate 67), reflects Renoir's interest in the human figure as well as his love of color. Renoir's influence can also be seen in the solidity of form and spatial organization. In short, Renoir's female nudes were prototypes for the work.

Another, equally important, reason for Rivera's attraction to Renoir was the French artist's use of people in their customary activities as subject matter. Rivera was already convinced that this theme was an indispensable aspect of painting. It was to become a dominant theme in future murals, easel paintings, and drawings. Rivera's 1920 canvas *The Grape Picker* (Plate 68) is indicative of his reaction to the work of Renoir, as well as the influence of Cézanne.

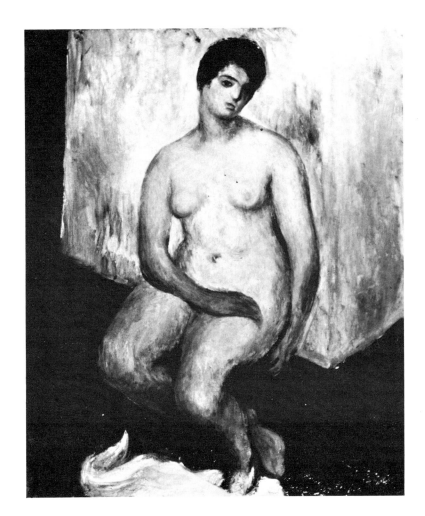

Plate 67. Nude, by Diego Rivera. Oil on canvas, 1920(?), about 12 x 15 in.

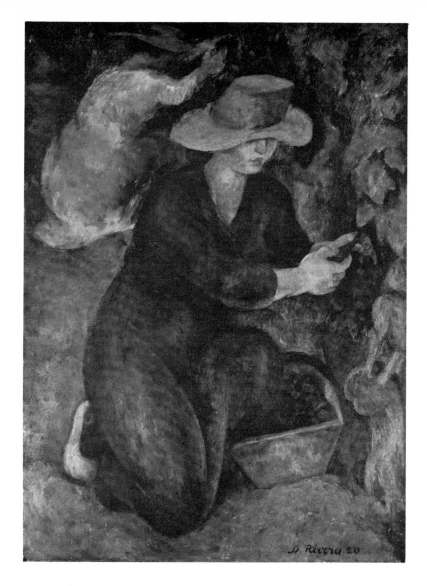

In contrast, the pencil drawing *Portrait of Jean Pierre Faure* (Plate 69), also executed in the significant year 1920, attests to the continuing influence of Picasso.

At this point, after ten years of intensive study and experimentation in France, Rivera felt that his European training was complete. Confident of his technical proficiency as well as of his understanding of the aesthetic problems of his art, Rivera was eager to begin an independent career.

The artist David Alfaro Siqueiros had arrived in Paris in 1919 and shortly afterward met Rivera. The meeting was a significant one for the future of Mexican politics and art. Siqueiros later said of it:

> That meeting, which I consider transcendental, represented the contact between an important period of European formalism,

(*Text continues on page 102.*)

Plate 68. The Grape Picker, by Diego Rivera. Oil on canvas, 1920, 0.675 x 0.485 m. Collection of Mrs. Frances Flynn Paine, New York City. Photograph (by José Verde O.) Courtesy of National Institute of Fine Arts, Mexico City.

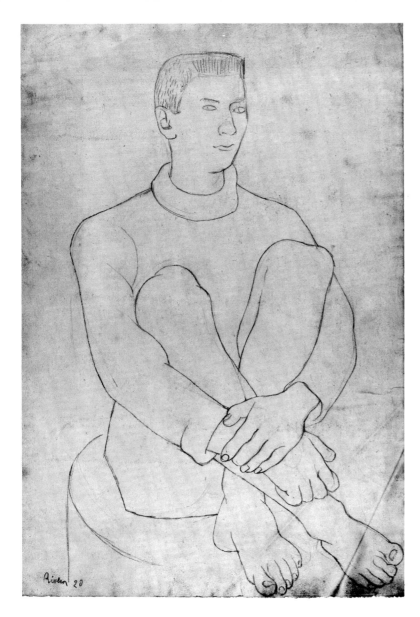

Plate 69. Portrait of Jean Pierre Faure, by Diego Rivera. Pencil drawing, 1920. Courtesy of The Art Institute of Chicago, Collection of David Adler.

the post-Cézanne, and the aspirations of the young Mexican painters who participated actively in the Revolution and were partisans of a new social art.[22]

The revolutionary Mexican government, born of years of struggle against dictatorship, was attempting to establish a new political and social order. Rivera and Siqueiros were concerned for the success of the program and eager to participate in it. Both men believed that the contributions of artists and of art were essential components of the program. They would further its objectives by creating pictorial murals in fresco—an art form already rooted in Mexican tradition.

It is believed that fresco painting began in Mexico in the first millenium B.C. and maintained a continuous tradition:

The third and fourth centuries saw the execution of those extraordinary frescoes which decorate numerous houses and temples at Teotihuacán [Plates 70 and 71]. This capital of the Mexican Tableland became a veritable centre for painters, who as in Florence under the Medici covered a good part of available wall space with magnificent art.

In its later phase, . . . that is, from the seventh to the ninth centuries, the Mayas painted frescoes of varying importance, . . . while at Bonampak [Plate 72] . . . the frescoes of pre-Columbian Mexico find their highest expression.[23]

The continuity of the mural tradition is demonstrated in churches of the colonial period, where it was customary to decorate the interiors with frescoes —usually limited to a palette of black and white with an occasional touch of burnt sienna or earth red. The general lack of color and the insistent linear quality of the paintings are attributable to the use of black-and-white wood engravings as models. These engravings were brought to the New World by the missionaries, who used them to illustrate stories from the Bible and the lives of the saints (Plate 73).[24] Other motifs, employed as decoration, include various conventionalized flower forms and representations of monsters. In certain early religious structures, such as the former Church and Monastery of San Nicolás (founded in 1548), at Actopan, Hidalgo, frescoes

Plate 70. Detail of Aztec mural from Teotihuacán, Mexico. Fresco. Courtesy Photo Archive, National Museum of Anthropology and History, Mexico City.

were so lavishly employed as to suggest elaborate Renaissance palace decorations. The primary function of murals in religious centers, however, was to propagate Christian concepts and to convert the Indians to Christianity. Later, murals were intended primarily to inculcate new social and political concepts.

Although dissimilar in spirit, another firmly entrenched aspect of the mural tradition, the *pulquería* painting (Plate 74), survived through colonial times and has retained its popularity to the present day. Such murals were painted on the outer adobe walls of otherwise unpretentious taverns where pulque was sold.[25] Usually humorous, the murals, with their droll, keen-witted, and ingenious titles, exemplify an earthy and characteristically Mexican approach to fantasy, as well as a poetic imagination.

These same qualities of fantasy and poetic imagination found further expression in certain canvas paintings with religious themes (Plate 75) and in

Plate 71. Detail of Aztec mural from Teotihuacán, Mexico. Fresco. Courtesy Photo Archive, National Museum of Anthropology and History, Mexico City.

the popular votive offerings (ex-votos, or *milagros*). Spanish in origin, religious in character, and anecdotal in content, these works are particularly distinguished by directness and artlessness of expression.

The ex-voto (Plate 76) describes and commemorates an act of supernatural intervention which, in response to prayer, has effected a miraculous escape from injury, illness, or disaster. It is a public offering of gratitude to the saint to whom the prayer was addressed and is customarily placed at the altar of the benefactor. Such a painting illustrates the accompanying text, which describes, usually in crude lettering, the circumstances of the miracle. The painting itself incorporates such essential and representative elements as the crisis, the donor, and the protector. Most such votive offerings are small and are painted in oils on tin. Their creators, often anonymous, are skilled, though not necessarily trained. They are characterized by meticulous technique; rich, bold color; naïve, simple forms not unlike those

Plate 72. Detail of mural from Maya ruins at Bonampak, Mexico. Courtesy Photo Archive, National Museum of Anthropology and History, Mexico City. Photograph by Giles Healy.

of other popular arts; and dramatic subject and composition. Often the unpremeditated result is that the work takes on the character of a surrealist painting. Thus the ex-votos also exemplify the continuity of a particular and characteristic aspect of indigenous pre-Columbian representation (Plate 77; see also Plate 18).[26]

In view of this long, rich, and varied artistic background in Mexico, the plan evolved by Rivera and Siqueiros to utilize murals as tools to define and expedite the objectives of the new social order was neither unique nor surprising. As sophisticated Mexicans and seasoned artists, both men were well aware of the precedent for just such narrative, descriptive, interpretative art. The effectiveness of the medium had long since been demonstrated in Europe as well as in Mexico. In consequence, they could not fail to

Plate 73. (*left*) *Mural in sixteenth-century Augustinian monastery, Acolman, Mexico, artist unknown. Photograph by Florence Arquin.*

Plate 74. (*facing*) Pulquería *murals in San Juan Teotihuacán, Mexico, artist unknown. Photograph by Florence Arquin.*

appreciate the existence of a latent but well-founded psychological basis for public acceptance of such a project, nor could they doubt that it would possess a direct and inherent appeal.

Furthermore, they could not have failed to recognize the emergence in Mexico of a sympathetic climate for the revival of mural painting under government sponsorship. Both painters were also aware of the contemporary precedent for such support: an ill-fated movement in mural painting, conceived as simple decoration, had been initiated with official sanction as early as 1910. Orozco, one of the artists who had participated in the earlier movement, wrote:

> In celebrating the centenary of Mexico's independence from Spain, Porfirio Díaz, then president of Mexico, had arranged for and financed a very large exhibition of contemporary Spanish painting in honor of the occasion. The group of young Mexican artists protested—not that they took excep-

Plate 75. Popular modern-day religious painting, artist unknown. Oil on canvas, 11¾ x 16½ in. Collection of Florence Arquin.

tion to the exhibition of Spanish works—but because nothing had been done for them, the very Mexicans whose independence was precisely the reason for the celebration. As champion of this group, Dr. Atl proceeded to raise the prerequisite funds with which to finance an independent exhibition.[27]

By his efforts Dr. Atl not only expedited the first major showing of canvases by these enthusiastic, determined, and talented young artists but also began to make the public aware of their current and potential contribution. Following the advice of Dr. Atl, the artists deliberately stressed Mexican themes—in contrast to Spanish ones—and in so doing introduced a distinctive element that would soon be identified with postrevolutionary Mexican art.

The brilliant and unequivocal success of the exhibition surpassed all hopes and intensified the enthusiasm and confidence of the participants. Moreover, and again at the instigation of Dr. Atl, it gave

Plate 76. Ex-voto, or milagro, painting, artist unknown. Oil. Courtesy of Museum of Popular Arts and Crafts, Mexico City.

rise to the Artistic Center, later known as the Society of Mexican Painters and Sculptors. The immediate purpose of the group was to urge the government to provide walls in public buildings on which the artists could paint. Orozco, a member of the society, subsequently described its short-lived success in achieving that goal:

> We petitioned the Ministry of Education for authority to decorate the walls of the recently completed amphitheater of the Preparatory School. Our request was granted. We apportioned the walls and erected our scaffolds. . . .
>
> The large exhibition of Mexican paintings had taken place in September, 1910. We began preparations to paint these walls in the following November. On the twentieth of that month, the revolution exploded. We panicked, and our projects were halted if not ruined.[28]

Interest in mural painting survived the an-

Plate 77. Tula-Toltec mask, coyote with human head between its jaws. Courtesy of Photo Archive, National Museum of Anthropology and History, Mexico City.

guished ten years of war and revolution, and as early as June, 1920—a year before Rivera's return to Mexico—murals were commissioned for a public building. José Vasconcelos, president of the University of Mexico and later minister of education, authorized the artists Roberto Montenegro and Xavier Guerrero to decorate the walls of the former Church of Saint Peter and Saint Paul in Mexico City. Painted in tempera and solely decorative in function, the murals embellished the pilasters and arches of the structure with festoons of stylized bird and flower motifs. Rivera was later to comment facetiously that the work was "potted, rather than painted, as the scheme leans to the curlicues found in much Mexican pottery."[29] Innocuous in theme and of no particular technical significance, the paintings nevertheless marked the modest beginning of Mexico's extraordinary renaissance in mural painting and represented an early predisposition for the official sponsorship of murals in public buildings. Further, as the continuance of a Mexican heritage, exemplified by the inclusion of Mexican motifs, they anticipated a major objective in the philosophy of the postrevolutionary regime. Moreover, the technical knowledge of Guerrero, one of the participating artists, was to provide "a vital link between the old craftsmen murals of house and pulquería painting and the new artist murals."[30]

NOTES FOR CHAPTER V

[1] In 1895, Vollard presented the first important collection of Cézanne's paintings in a one-man show and set a precedent by "devoting not only all his walls, but the window space as well" to canvases by one artist. "This exhibition was to a large degree responsible for Vollard's success as a dealer, for it brought him, as of 1896, an entirely new group of painters. . . . A Van Gogh exhibition—the most complete there has ever been—marked the opening of a gallery at No. 6, Rue Lafitte. . . . In 1904, it was the scene of the first Matisse exhibition" (Pascal Pia, "The Sleeping Midas of Art," in *The Selective Eye*, 184).

[2] Conversation with Rivera.

[3] In 1908 and 1909, Rivera traveled in France, Belgium, England, and Holland.

[4] John Rewald (ed.), *Cézanne's Letters*, 233.

[5] Alfred H. Barr, Jr., *Cubism and Abstract Art*, 69.

[6] "In 1906 Matisse buys Negro Statuettes from Sauvage, a curio-dealer in Paris" (Maurice Raynal, *Modern Painting*, 13).

[7] Stein, *Picasso*, 23.

[8] The fauvist movement (from the French *fauve*, meaning "wild beast") had its greatest period of activity and influence between 1907 and 1914. Fauvist art is generally marked by brilliant, intense, and often violent color, as well as by an interest in surface textures and pattern.

[9] These collections were later "nationalized by decree of the People's Commissars. Today those of Morosov and Stchoukine form what is called in Moscow, The Museum of Western Art" (Lionello Venturi, *Picasso in Russia*, 10).

[10] Barr, *Cubism and Abstract Art*, 120, 126.

[11] *Fifty Years of Modern Art*, intro. by Emile Langui, 296.

[12] Diego Rivera (with Gladys March), *My Art, My Life*, 107.

[13] Rivera was then living with his Russian wife Angeline Beloff; Picasso, with Olga Koklova, also a Russian. Ilya Ehrenburg, *People and Life, 1891–1921*, New York, Alfred A. Knopf, 1962.

[14] Rivera, *My Art, My Life*, 114.

[15] In his youth Braque, the son of a house painter, had learned to prepare and apply the special paints used on doors, walls, and fireplaces to create the illusion of wood and of marble. This technique, which he used in his cubist paintings of the synthetic period, was soon adopted by fellow artists of the group.

[16] *Diego Rivera*, Catalogue, 38.

[17] Conversation with Rivera.

[18] José Juan Tablada, *Mexican Painting Today*, Vol. LXXVI, No. 308 (January, 1923), 276.

[19] Conversation with Rivera.

[20] Later, in Mexico, Rivera would repeatedly say that Seurat was one of the truly great painters of that period (conversation with Rivera).

[21] "Apollinaire and Picasso, by bringing to light the genius of Le Douanier Rousseau . . . had already opened people's eyes to this (naïve) art, before 1914" (*Fifty Years of Modern Art*, 45).

[22] Erico Verissimo, *Mexico*, 280.

[23] *Mexico: Prehispanic Painting*, 11–12.

[24] Excellent examples of this type of mural are to be found in the Franciscan Church and Monastery of San Miguel (1529–70) at Huejotzingo, Puebla.

[25] Adobe walls are especially suited for fresco or tempera. Pulque is a native drink which because of its low cost is especially popular with the poor and underprivileged.

[26] These paintings were recognized as an authentic art form by Diego Rivera, Frida Kahlo, Miguel Covarrubias, and Frederick W. Davis, among others.

[27] Orozco, *Autobiography*, 30.

[28] *Ibid.*, 30–31.

[29] Jean Charlot, "Murals Revisited," *Magazine of Art*, February, 1946, 58, 59.

[30] George Woodcock, "Mexican Muralist," *The Arts*, April, 1961, 26.

STUDIES IN ITALY, 1920-1921

Six months before the first official mural was commissioned in Mexico, Rivera left France for Italy. Looking forward to his return to Mexico and having determined to paint murals of political and social significance there, he now—and with characteristic thoroughness—took a first step in that direction. The great mural tradition of the Italian Renaissance was to provide the foundation for the success of his own ambitious plans.

Once in Italy, Rivera devoted himself to seventeen months of intensive study. With typical enthusiasm he steeped himself in the great mural tradition of such masters as Paolo Uccello, Pietro and Ambrogio Lorenzetti, Raphael, Luca Signorelli, and Michelangelo. The wide scope of Rivera's interests is indicated by his sketches. In subject they range from figure drawings (Plates 78 and 79), portraits

(Plate 80),[1] and landscapes (Plate 81) to renderings of architecture (Plate 82), sculpture (Plates 83 and 84), and paintings (Plates 85 to 87). Whether executed with his characteristically crisp, incisive line or by means of subtle modeling to emphasize form, Rivera's drawings demonstrate the fastidiousness of his draftsmanship. This quality is dramatically illustrated by placing one of his drawings (Plate 87) in juxtaposition with his source—illustrated here by a photograph of an eighth-century Byzantine painting *Crucifixion* (Plate 88) in the ancient Church of Saint Mary in Rome.

Rivera's particular faculty for grasping the innate character of his subject is again illustrated by his interpretations of Etruscan sculpture. His studies of a group of female figures (Plates 89 and 90), when examined alongside photographs of similar sculpture (Plate 91), reveal his emotional response to the intense vitality, the ingratiating charm, and the plastic

Plate 78. Standing Female Nude, by Diego Rivera. Pencil drawing, 1919–20. Originally from the Angeline Beloff Collection, Mexico City. Courtesy of Gallery of Mexican Art, Mexico City.

and decorative qualities of these realistic terra-cotta pieces. In more objective and serious mood are his drawings of an Etruscan warrior (Plates 92 and 93; compare Plate 94), in which he carries simplification of three-dimensional form into the realm of flat pattern.[2]

Throughout the months Rivera devoted to the technical aspects of fresco painting, he remained eager to renew this ancient and singularly functional technique in the murals he planned to execute in Mexico. Years later, long after his objective had been attained, Rivera was to say:

I preferred Fresco because in it all materials are analogous to the materials of architectural construction. Monumental painting does not have ornamentation for its objective, but the prolongation of the life of the architecture beyond time and space. Nat-

Plate 79. Man Seated at Table, *by Diego Rivera. Pencil drawing, 1920–21. Originally from the Angeline Beloff Collection, Mexico City. Courtesy of Gallery of Mexican Art, Mexico City.*

urally, this cannot be realized if the roots of the painting do not penetrate deeply into architecture.[3]

Rivera's travels in Italy enabled him to study the classical background of European art. At the same time he succeeded in mastering the long-lost technique of encaustic.[4] He had been experimenting with the method as early as 1905. At that time, he and a friend, Pancho de la Torre, had achieved an emulsion of wax and pigment which, when cold, solidified and had the quality of crayon. Although they did not realize it, they had rediscovered the method of encaustic painting. Six years later, in Paris, Rivera undertook a series of additional experiments in pursuit of encaustic, working with another Mexican artist, Enrique Freyman. Rivera said:

> I recalled my earlier experiences in Mexico in my search for solid oil colors, but now I

(*Text continues on page 128.*)

Plate 80. Head of a Woman, by Diego Rivera. Pencil drawing, ca. 1920, 12 x 19 cm. Originally from the Angeline Beloff Collection, Mexico City. Courtesy of Gallery of Mexican Art, Mexico City.

Plate 81. Landscape with Palm Trees, *by Diego Rivera. Pencil drawing, 1920–21. Originally from the Angeline Beloff Collection, Mexico City. Courtesy of Gallery of Mexican Art, Mexico City.*

Plate 82. Church of Santa Sophia (*Italy*), *by Diego Rivera. Pencil drawing, 1921. 13.0 x 20.5 cm. Originally from the Angeline Beloff Collection, Mexico City. Courtesy of Gallery of Mexican Art, Mexico City.*

Plate 83. Sketch of sculpture by Diego Rivera (horse attributed to Verrocchio). Pencil drawing, 1920–21, 12.5 x 20.0 cm. Originally from the Angeline Beloff Collection, Mexico City. Courtesy of Gallery of Mexican Art, Mexico City.

Plate 84. Head suggesting Roman sculpture, by Diego Rivera. Pencil drawing, 1920–21. Originally from the Angeline Beloff Collection, Mexico City. Courtesy of Gallery of Mexican Art, Mexico City.

Plate 85. Study of three men, suggesting Renaissance painting, by Diego Rivera. Pencil drawing, 1920–21. Originally from the Angeline Beloff Collection, Mexico City. Courtesy of Gallery of Mexican Art, Mexico City.

Plate 86. Study suggesting detail of painting of a man in armor, by Diego Rivera. Pencil drawing, 1920–21, 18.5 x 23.0 cm. Originally from the Angeline Beloff Collection, Mexico City. Courtesy of Gallery of Mexican Art, Mexico City.

Plate 87. Study of figures in eighth-century Byzantine fresco, Church of Santa María Antiqua, Rome, by Diego Rivera. Pencil drawing, 1920–21. Originally from the Angeline Beloff Collection, Mexico City. Courtesy of Gallery of Mexican Art, Mexico City.

Plate 88. Crucifixion, *eighth-century Byzantine fresco, Church of Santa María Antiqua, Rome. Photograph by Alinari.*

Plate 89. (far left) Study of female Etruscan clay figures, by Diego Rivera. Pencil drawing, 1920–21. Originally from the Angeline Beloff Collection, Mexico City. Courtesy of Gallery of Mexican Art, Mexico City.

Plate 90. (left) Study of female Etruscan clay figures, by Diego Rivera. Pencil drawing, 1920–21. Originally from the Angeline Beloff Collection, Mexico City. Courtesy of Gallery of Mexican Art, Mexico City.

Plate 91. (right) Venus and Venus Céleste, female Etruscan clay figures, Louvre Museum, Paris. Photograph by Alinari.

Diego Rivera.

Plate 92. (*far left*) *Study of bronze sculpture* Etruscan Warrior, *by Diego Rivera. Line drawing, 1920–21. Originally from the Angeline Beloff Collection, Mexico City. Courtesy of Gallery of Mexican Art, Mexico City.*

Plate 93. (*left*) *Studies of bronze sculpture* Etruscan Warrior, *by Diego Rivera. Line drawing, 1920–21. Originally from the Angeline Beloff Collection, Mexico City. Courtesy of Gallery of Mexican Art, Mexico City.*

Plate 94. (*right*) Etruscan Warrior. *Bronze. Etruscan Museum, Florence, Italy. Photograph by Alinari.*

wanted the traditional encaustic with its solidity, purity, depth, and richness of colors. . . . Despite many experiments I had not found the true encaustic. I now turned to the National Library of Paris and to old books which dealt with the fountainhead for these studies—the ancient Greeks, Romans, and Egyptians—and which described this technique in detail.[5]

Rivera later employed the technique in his first mural in Mexico. Then, convinced that he had mastered it and fully understood its merits and limitations, he lost interest in it and never again employed it in a major work. He turned instead to fresco, which remained his avowed and demonstrated preference throughout his long career in mural painting.

Italy's ancient cultures also aroused Rivera's interest in the use of mosaic. Both this medium and fresco had been widely used in Mexico's own indigenous Indian past (Plates 95 and 96).

During his sojourn in Italy, Rivera visited and studied that country's rich legacy of classical art at such famed sites as Pompeii and Rome. He was particularly impressed by the murals at Pompeii. Representative of the classical background in fresco painting there—other than the early use of sharply contrasted panels of brilliant color that divided walls —was the development of purely ornamental, theatrical, and architectural styles. Subject matter drawn from historic, religious, and mythological sources demonstrate the Roman insistence upon realism (Plate 97), an attribute that was especially pertinent to Rivera's plans for the murals he would paint in Mexico.

The true stature of fresco painting at Pompeii can best be seen in a large fresco excavated from the Villa of the Mysteries. This mural has been described as the "most beautiful example of painting from Roman antiquity and the most notable record of ancient painting and of the ancient religion of the Mysteries."[6] The same intrinsic qualities of realism, illusionism, and narrative that distinguish Roman art in various other media are once again evidenced here. But, unlike other wall decorations of the period, this fresco achieves the quality of truly great, monumental painting by the sheer grandeur of the original concept; by the calm, objective dignity of expression; the direct, simple statement; the richness of color; and the imposing, statuesque representation of the

Plate 95. Maya-Toltec mosaic, representing the Serpent of the Sun, found in substructure of the Temple of Kukulcan, Chichén Itzá, Mexico. Courtesy of National Museum of Anthropology and History, Mexico City.

Plate 96. Maya mosaic mask encrusted with turquoise and jade, teeth and pupils of eyes made of shell. By courtesy of the Trustees of the British Museum.

human figure. Furthermore, a deeply moving, profound, and sustained mood of ritual permeates the entire painting. Although organized within the architectural framework of the wall as a series of panels that portray various aspects of the main theme, the composition is nevertheless unified, coherent, and uninterrupted in its established lateral movement. The subject is realized in shallow space that is abruptly terminated by a flat, rich red background, which also functions as a strong unifying element. Because of these technical aspects of the composition, this fresco may be construed as a forerunner of the Italian Renaissance. These same characteristics were later to distinguish the work of the early Renaissance masters. Both sources—ancient Roman and Renaissance—were to influence Diego Rivera.

Also illustrative of the classical traditions found at Pompeii is the large mosaic floor decoration *Battle of Alexander* (Plate 98), excavated from the House of the Faun. This work, said to be a fragment from the still larger mosaic *Battle of the Issus*, describes "the decisive encounter in the war between Alexander, the Macedon, and Darius, king of the Persians."[7] Despite the use of mosaic, this violent,

dramatic composition assumes the character of a painting, and is believed to "derive from a celebrated [Greek] painting by Philoxenos of Eretria or Helen of Timon."[8]

In contrast, the delightful *Landscape of the Nile* (Plate 99), which is described as "a frame for the Alexander mural . . . and alludes to Egypt, which was subject to his empire,"[9] exemplifies the traditional use and aesthetic effect of mosaic. Conspicuous here are the simple, concise, and rigid pattern; the bold silhouette; and the rich, contrasting colors defining the sharp contours of flat, decorative subject matter.

Rivera's interest in mosaic technique soon took him to Venice and Ravenna. In the churches of those cities he found the magnificent and awe-inspiring mosaic murals of the Byzantine-Christian era (Plate 100). In these sumptuous mosaics, influenced by Eastern art, gold tesserae were often used for backgrounds, against which were flat areas of rich color vibrating in luminous, resplendent contrast. Subtle distinction in the representation of divinities, human beings, animals, and landscapes was enhanced by the solemn dignity, formality, and sym-

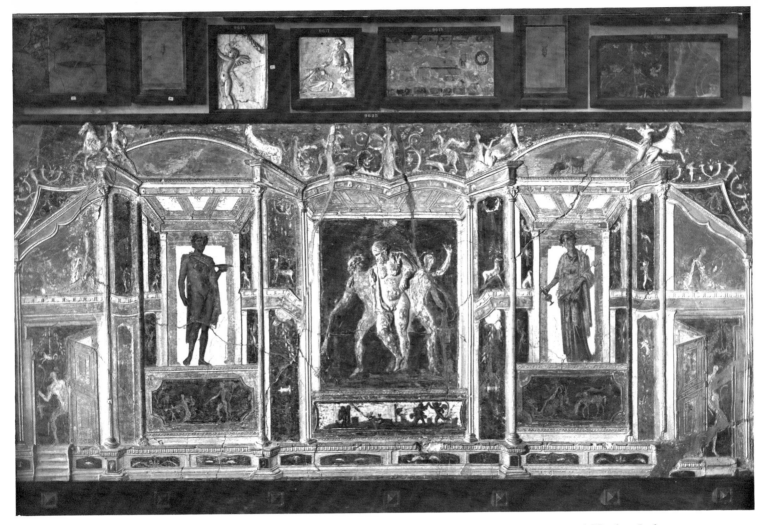

Plate 97. Wall from Pompeii, decorated with painting and stucco, now at the National Museum of Naples, Italy. Photograph by Alinari.

Plate 98. Battle of Alexander, *mosaic floor decoration from Pompeii, now at the National Museum of Naples, Italy. Photograph by Alinari.*

Plate 99. Landscape of the Nile, *mosaic from Pompeii, now at the National Museum of Naples, Italy. Photograph by Alinari.*

bolism of an essentially decorative but somewhat humanized art, consecrated to the specific doctrinal needs of the church. Subsequently, when Rivera had occasion to refer to these murals, it was always with a broad smile of pleasure, accompanied by his favorite word of high praise—"marvelous."

In the middle 1940's, Rivera was to begin a series of experiments in mosaics on the walls, ceilings, and pavements of his home in Coyoacán (Plate 2). For those experiments he used indigenous Mexican Indian technique, combining irregular bits of native stone in a variety of shapes, sizes, and colors, rather than the traditional small glass tesserae. His later murals—of which there were to be many—were executed in both the native tradition as well as in that of the Italians and Byzantines, depending upon function and suitability.

The same intrinsic pictorial qualities that distinguish narrative and didactic murals in both fresco and mosaic may be found in the sculptured Italian friezes that commemorate significant historical events and the exploits of famous heroes. The Trajan Column in Rome is typical of such monuments (Plates 101 and 102). A sculptured frieze, estimated

133

to be 600 feet long and to include 2,500 figures, spirals from base to tip of the tall shaft.[10] The Roman interest in illusionism is again conspicuous here, accomplished in this medium by the strong and bold relief of the foreground figures in contrast with the gradual reduction to low relief in the modeling of the background. Of more immediate consequence to Rivera was the method of organization, whereby continuous narrative was achieved through a series of closely related compositions dedicated to the portrayal of a particular theme. In this column the sculpture illustrates the major events in the emperor Trajan's wars against the Dacians.[11] It was a precedent that not only reinforced Rivera's own ambitious resolve to instill pride in country and heritage through the medium of art but at the same time provided a diagrammatic framework for achieving that goal. Furthermore, the epic character of the sculpture confirmed Rivera's decision to employ a poetic—even philosophical—portrayal of the saga of Mexico as his theme with murals in fresco as his tool.

The sculptured frieze may have inspired Rivera's early introduction of panels painted in grisaille (Plate 103)—which simulates sculpture in tones of gray—as an extension of his first murals in fresco at the Ministry of Education in Mexico City. Again, Rivera may have chosen to introduce such monochromatic painting as a foil for the rich color of his other murals at the ministry.

Later, at the National Palace—and at Cuernavaca and in subsequent murals—Rivera sought to establish a further optical illusion of sculpture in architectural decoration (Plate 104), as well as in the actual painting (Color Plates 11 and 12 and Plates 105 and 106). There his use of grisaille in a long narrow band at the base of the major fresco and his inclusion of a series of small panels, related in theme to the large mural above it, show that he had studied the predella in Italian painting. The concomitant band of grisaille painting was to characterize all of Rivera's later murals. As his technique evolved, however, he began to add notes of color to the grisaille

(*Text continues on page 139.*)

Plate 100. Apse of the Basilica of San Vitale, Ravenna, Italy. Sixth-century mosaic. Photograph by Alinari.

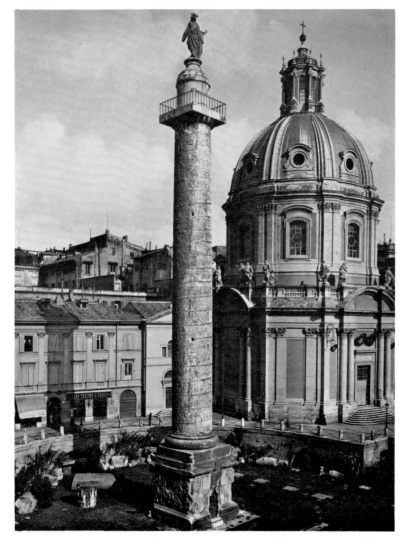

Plate 101. (left) *The Trajan Column, Rome, Italy. Bas-relief. Photograph by Alinari.*

Plate 102. (facing) *Detail of the Trajan Column, Rome, Italy. Bas-relief. Photograph by Alinari.*

paintings—which were to modify their effectiveness and impair the original impression of sculpture.

Rivera's years of study in Europe had encompassed the trends and techniques of contemporary painting. His studies in Italy rewarded him with an understanding of the great mural tradition of the Renaissance. There he acquired an awareness of the basic architectural character of murals and of the prerequisite need for direct, simple statement and organization, as well as an equally informed understanding of form and color to evoke a calculated emotional response. He was challenged and invigorated as he examined Italy's legacy of Greek, Etruscan, and Roman cultures which had endowed the Renaissance with its humanistic qualities and forceful tradition of realism. These salient traits had resulted in portraiture that was generally distinguished by elegance, superb technical skill, and keen interpretation of personality. The same qualities are

Plate 103. Panel in the Ministry of Education, Mexico City, by Diego Rivera. Fresco, grisaille, 1924. Photograph by Florence Arquin.

to be found in Rivera's portraits, even his earliest ones. But it was the humanism inherent in the Renaissance emphasis upon mankind in general and the individual in particular, as well as the narrative and didactic role of Renaissance murals, that drew Rivera to the Italian masters. That these qualities should have possessed a powerful appeal for Rivera is attributable not only to his own political and social sympathies—founded largely in the liberal beliefs of his father and his teacher Posada—but also because they now coincided with Rivera's own emotional, intellectual, and philosophic convictions.

Moreover, he was particularly impressed by the revival of interest in Italy in its own classical heritage, as well as by its emphasis upon subject matter in painting, sculpture, and the minor arts, deliberately designed to reinforce and accelerate the classical revival. In the classical myths and forms of Renaissance art Rivera recognized a specific device and mode of procedure by which the ambitions of Mexico's new postrevolutionary government could be achieved. Just as the Italian Renaissance artists had revived pride in their country's heritage from ancient Greece

(*Text continues on page 143.*)

Plate 104. (*left*) The World Owes to Mexico . . ., *panel in the National Palace, Mexico City, by Diego Rivera. Fresco, grisaille, 1944–45. Photograph by Florence Arquin.*

Plate 105. (*facing*) Tenochtitlán, *mural in the National Palace, Mexico City, by Diego Rivera. Fresco, 1944–45. Photograph by Florence Arquin.*

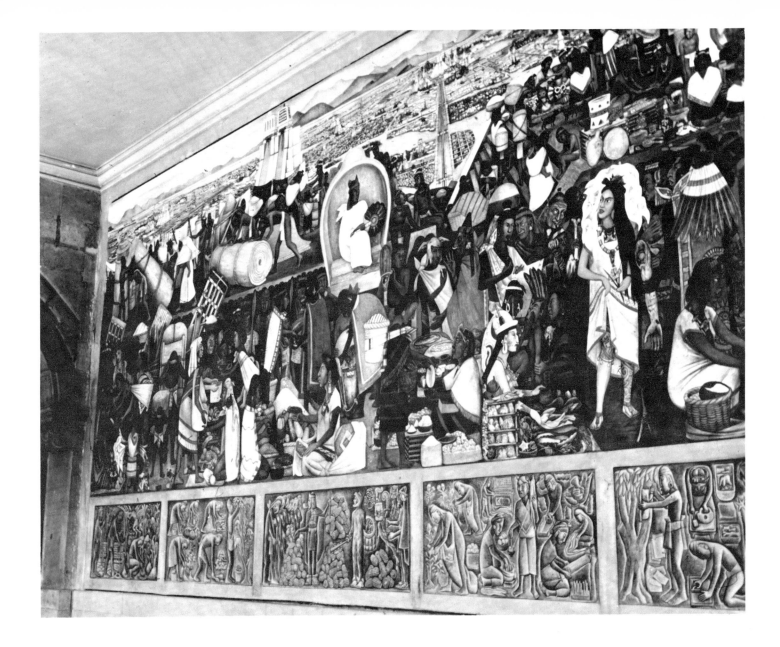

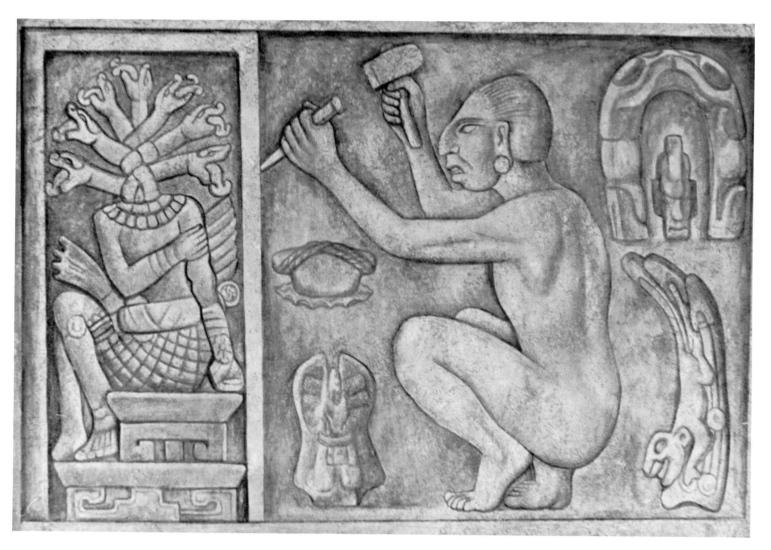

and Rome, so Rivera, with similar emphasis upon realism and humanism, would create murals in Mexico that would evoke a pride in the heritage of a rich indigenous past.

Now that he had studied all phases of classical and Renaissance painting in Italy, Rivera was eager to take his place in the projected renaissance in his own country. Europe had endowed him with a prodigious cultural background, but Mexico was to confirm his artistry.

In July, 1921, this man with a mission, possessed of the skills, knowledge, and philosophy to achieve his purpose, returned to Mexico. Once again in his homeland, disregarding the easy path to popularity and great wealth that he could have chosen, he followed the more difficult one that ultimately brought him immortality as artist-historian of Mexico. In that role and in his revival of fresco painting, he was to have international influence on the world of art.

Plate 106. Detail of panel under mural The Totonac Culture, *by Diego Rivera. Fresco, grisaille, 1944–45. Photograph by Florence Arquin.*

NOTES FOR CHAPTER VI

[1] In my opinion, this drawing of a woman's head is probably a stylized rendering of a living model which reflects Rivera's interest in Roman sculpture.

[2] Rivera's interest in Etruscan sculpture was prophetic since it foreshadowed a later and dedicated admiration for Mexico's Tarascan sculpture, which is characterized by similar subject matter, material, and plastic qualities.

[3] *Diego Rivera* (catalogue, November 15–December 25, 1930, San Francisco, California Palace of the Legion of Honor), foreword by Katherine Field Caldwell.

[4] A technique employing melted wax mixed with paint which, after application, is treated with heat. "The method was employed by the Greeks and Romans as one method of painting upon panels or walls. It was also a favorite method of painting employed by the early Christian artists and was practiced, though in diminishing degree until the middle of the 14th century or even later, when it became obsolete" (James Ward, *History and Methods of Ancient and Modern Painting*, I, 55).

[5] *Diego Rivera: Fifty Years of His Work*, 269.

[6] Amedeo Maiuti, *Pompeii*, 78.

[7] National Museum of Naples, *Catalogue*, Fig. 115.

[8] *Ibid.*

[9] *Ibid.*, Fig. 114.

[10] Ludwig Curtis, *Rome*, 30.

[11] *Ibid.*

BIBLIOGRAPHY

Barr, Alfred H., Jr. *Cubism and Abstract Art.* New York, Museum of Modern Art, n.d.

———, ed. *Masters of Modern Art.* New York, Museum of Modern Art, 1958.

Charlot, Jean. *Art from the Maya to Walt Disney.* New York, Sheed and Ward, 1939.

———. "Murals Revisited," *Magazine of Art*, February, 1946.

Chicago Daily Tribune, November 26, 1957.

Clifford, Henry. *Notes on Velasco's Paintings.* Catalogue, Philadelphia, Centennial Exhibition, 1944–45, Philadelphia, Philadelphia Museum of Art.

Curtis, Ludwig. *Rome.* New York, Pantheon Books, 1950.

Diego Rivera. Catalogue, November 15–December 25, 1930. San Francisco, California Palace of the Legion of Honor.

Diego Rivera: Fifty Years of His Work. Text by Juan O'Gorman, "Report on a Dissertation by Diego Rivera Concerning the Techniques of Encaustic and Fresco Painting." Mexico City, Department of Plastic Arts, National Institute of Fine Arts.

Excelsior (Mexico City), December 8, 1957 (special supplement).

Fifty Years of Modern Art. Intro. by Émile Langui. New York, Frederick A. Praeger, 1959.

Gamboa, Fernando. *Posada: Printmaker of the Mexican People.* Catalogue. Chicago, Chicago Art Institute, 1944.

Gardner, Helen. *Art Through the Ages.* New York, Harcourt, Brace, 1948.

Hilton, Ronald, ed. *Who's Who in Latin America.* 3d ed. Stanford, Stanford University Press, 1946.

Life Magazine, December 9, 1957.

Maiuri, Amedeo. *Pompeii.* Geographical Institute of Agostini-Novara, 1961.

Mexico: Prehispanic Painting. Intro. by Ignacio Bernal. New York, New York Graphic Society with UNESCO, 1958.

National Museum of Naples. *Catalogue.* Naples, S. A. Richter and Company, n.d.

New York Times, November 25, 1957.

Orozco, Jose Clemente. *Autobiography.* Mexico City, Ediciones Occidente, 1945.

———. "The Stimulus of Posada," *Massachusetts Review,* Vol. III, No. 2 (reprint).

Pellicer, Carlos. "The Valley of Mexico," *Mexico City News,* December 20, 1958.

Pia, Pascal. "The Sleeping Midas of Art," in *The Selective Eye.* New York, Random House, 1955.

Posada, Jose Guadalupe. *100 Original Woodcuts by Posada.* Intro. by W. S. Stallings, Jr., Foreword by Jean Charlot. Taylor Museum, Colorado Springs; Mexico City, Vanegas Arroyo, 1947.

Raynal, Maurice. *Modern Painting.* New York, Skira, 1956.

Rewald, John. *A History of Impressionism.* New York, Museum of Modern Art, 1946; rev. ed., 1961.

———, ed. *Cézanne's Letters.* London, Bruno Cassirer, 1941.

Rivera, Diego. "Dynamic Detroit: An Interpretation," *Creative Arts,* 1933.

———. "José Guadalupe Posada: A Magisterial Utilization of Clean Bones," *Massachusetts Review,* Vol. III, No. 2 (reprint).

———. "The Work of José Guadalupe Posada, Mexican Engraver," *Mexican Folkways*, 1930.

——— (with Gladys March). *My Art, My Life.* New York, Citadel Press, 1960.

Runes, Dagobert D., and Harry G. Schrickel, eds. *Encyclopedia of the Arts.* New York, Philosophical Library, 1946.

Smith, Robert C. "Three Brazilian Landscapes of Frans Post," *Arts Quarterly* (Detroit Institute of Arts), Vol. I (1938), 246.

Stein, Gertrude. *Picasso.* Boston, Beacon Press, 1959.

Tablada, José Juan. *Mexican Painting Today*, Vol. LXXVI, No. 308 (January, 1923).

Time Magazine, March 10, 1958, October 11, 1954.

Toor, Frances. *Twelve Reproductions in Color of Mexican Frescoes by Diego Rivera.* Mexico City, Fishgrund Publishing Company, n.d.

Universal (Mexico City), November 26, 1957.

Upjohn, Everard M., Paul S. Wingert, and Jane Gaston Mahler. *History of World Art.* 2d ed., rev. and enl. New York, Oxford University Press, 1958.

Venturi, Lionello. *Picasso in Russia.* Rome, L'Obelisco, 1954.

Verissimo, Erico. *Mexico.* New York, Dolphin Books and The Orion Press, 1962.

Ward, James. *History and Methods of Ancient and Modern Painting.* Vol. I. London: Chapman and Hall, 1913–21.

Woodcock, George. "Mexican Muralist," *The Arts*, April, 1961.

INDEX